# British Art Pottery
# 1870-1940

# British Art Pottery
# 1870-1940

A. W. Coysh

**Charles E. Tuttle Company : Publishers**
Rutland, Vermont

*By the same author*

Blue and White Transfer Ware, 1780–1840
Blue-printed Earthenware, 1800–1850
Collecting Bookmarkers
The Antique Buyer's Dictionary of Names

Published by the Charles E. Tuttle Company, Inc.
of Rutland, Vermont & Tokyo, Japan
with editorial offices at
Suido 1-chome, 2-6, Bunkyo-ku, Tokyo, Japan

Library of Congress Catalog Card No. 76-6748
International Standard Book No. 0-8048-1202-0

Printed in Great Britain

# Contents

# Introduction

Industrial developments in the first half of the nineteenth century produced a growing feeling in artistic circles that men were becoming slaves to the machine. Artists deplored what Frederic Leighton called 'indifference to the presence of the ugly'. In the 1860s William Morris channelled these feelings, expounding his view that all creative work should be artistic in essence and appeal to the whole man, the emotions and intellect through the senses. At the same time John Ruskin was attacking materialism, expressing views that provoked heated discussion, especially among instructors and students in the schools of art.

By 1870 the Arts and Crafts movement was having a growing influence on production. A number of potteries began to produce wares thrown and decorated by hand. The main centres producing this new 'art pottery' were in London but within a short time art potteries appeared in the provinces.

In the 1880s the 'Arts and Crafts Exhibition Society' began to organise displays of art pottery. The chairman was Walter Crane who had already designed decorative tiles and pottery for Wedgwoods of Etruria in Staffordshire and for Maw & Co of Broseley in Shropshire. He expressed the new artistic philosophy:

> From the great universal storehouse every artist after his kind quarries out his material. Years of work and experiment teach him its properties, and give him facility in dealing with it, until he finally forms from it the speech and language which seems to him best fitted to embody and convey to the world what he has in his eye and his mind.

Crane's influence continued until his death in 1915. By this time, however, other forces had been at work. *Art nouveau* styles invaded ceramics and artist-potters who had equipped themselves with technical knowledge became intensely interested in the fine glazes on Chinese wares. After much experiment they produced fine new glazes of their own. Notable among these craftsmen-chemists were Bernard Moore, William and Joseph Burton, and W. Howson Taylor.

In the early years of the twentieth century several potters in the art schools started to produce pottery on their own –

throwing, decorating and firing their own wares. However, the day of the true studio potter did not come until after World War I when Bernard Leach and William Staite Murray pioneered a new movement, spreading their philosophy that the artist-craftsman could do his best work only by controlling the whole process from clay to decorated pot, working alone or with a few chosen helpers or apprentices.

The term 'art pottery' was first widely used in late Victorian times. In this book it is used to describe pottery that owes its design and general appearance to the artistry of an individual or a small team working together on an agreed plan. It is synonymous with 'Studio Ceramics', the term often used in auction salerooms.

# Art Pottery Decoration

The techniques involved in the decoration of art pottery differ greatly. Sometimes designers, throwers, modellers, painters and glazers worked as a close-knit team to an agreed plan; other potters were personally involved in the whole process. There was no mass production so the wares from each pottery have their own characteristics which the keen collector will soon come to recognise.

Many art potteries were sited where suitable clay was available. This is why so many were grafted on to existing brickworks or tileworks. The local clay could, if necessary, be mixed with clays brought from other areas; a few art potteries imported all their clay, at least for certain types of ware. Careful preparation of the clay was important. It had to be crushed, sifted and kneaded either by hand or in a pug mill before a pot could be made. Air was often driven out by beating one piece against another or by cutting it through again and again with a wire. A thrower shapes the clay between the thumb, fingers and palm of the hand as it spins on a circular table. In small workshops a wheel boy kept the wheel spinning, a bench boy prepared the clay while the thrower concentrated on shaping the pot either to a pattern or to a shape of his own choice. Once a newly thrown pot has been air-dried, various decorative operations can be carried out before the clay becomes too hard to work.

*Turning* was used extensively especially by makers of terracotta, either to produce grooves encircling the pot, or a raised ridge by cutting away part of the body. So expert were the turners of the Torquay Terracotta Company in late Victorian times that the firm was awarded a medal by the Turners' Company.

*Sgraffito Decoration* involved the scratching of a design in the clay body while still soft. This technique was used on stoneware in the Doulton Lambeth pottery by Hannah Barlow and her sister. The little grooves scratched in the clay were filled with colour to emphasise the design (Fig 1). Variations of the *sgraffito* technique include stamping, carving and inlay work.

*Slip Decoration* involved the use of white clay diluted to the

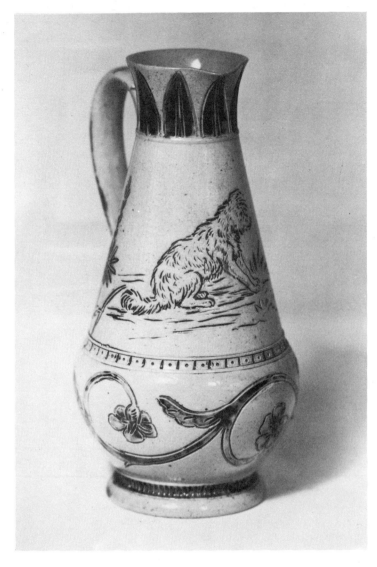

1. Doulton stoneware jug
(*c* 1872) with *sgraffito*
decoration by Hannah Barlow
and stylised foliage glazed a
dark brown. Impressed mark:
DOULTON LAMBETH
within an oval, an incised
artist's monogram. 23 cm

consistency of cream, sometimes coloured by the addition of a
pigment. Slip was used to cover the whole body of red wares.
The layer was then cut, incised or scratched to reveal the red
clay beneath which formed the pattern or design. The technique
has been used in the Barnstaple-Bideford area of North Devon
since the eighteenth century and was extensively used in South
Devon in late Victorian times on souvenir motto wares.

*Applied Decoration* involves modelling a design and then
casting it by filling a dry plaster mould with slip. The plaster
absorbs the moisture and when the slip has dried out it can be
removed from the mould and fixed to the body of the pot. Slip
can be prepared which will keep its colour after firing. This can
be trailed from a bag or tube, or brushed on the surface of a pot

as decoration. Clay can also be used in a firmer state for pâte-sur-pâte decoration. Layers of clay are applied to the body and then modelled. The horses on the Hannah Barlow vases (Fig 6) were created in this way.

*Painted Decoration* can be applied direct to the clay body after firing but it is usually desirable to cover the biscuit with a layer of white or cream coloured glaze before painting. Tin glazed wares on the continent of Europe have always been referred to as *faience*. This has been loosely applied in Britain to any painted wares on a light ground. A clear glaze is usually present to protect the colours. Faience was produced by the Burmantofts and the Doulton potteries.

*Lustre Decoration* involves the application of a brilliant metallic film which reflects the light. Silver, gold and copper lustres have been used since the beginning of the nineteenth century. William De Morgan used pink and red lustres in the 1880s and 1890s and the Pilkington's Lancastrian wares were produced with new lustre shades in the years before World War I.

*Coloured Glazes* have been widely used to decorate art pottery during the present century. Glaze is applied as particles of powder suspended in water. In the glost furnace these combine with the body of the ware to which they become firmly welded. Protective glazes are usually transparent though they sometimes have a matt surface resulting from the formation of thousands of minute crystals.

By adding oxides of metals to the glazing liquid it is possible to produce coloured glazes. The colours depend on the composition of the glaze, the amount of oxide used, the composition of the body and the temperature to which the decorated wares are raised. In general the colours produced by the various oxides are:

Chrome – bright green
Chrome and zinc – brown
Chrome and tin – pink
Cobalt – shades of blue
Copper – green
Gold – purple and red
Iron – brown, red or yellow
Manganese – brown, violet or black
Nickel – brown or violet
Tin – white
Uranium – yellow or orange

Between 1900 and 1914 many experiments were made by craftsmen-chemists and a number of new styles of glaze decoration were evolved. Glazes were sometimes allowed to run causing one colour to shade into another. If it was desirable to keep them apart a thin line of slip was used to separate the areas to be treated with different colours. Some glazes when fired at a high temperature produced a mottled effect. The variations were almost unlimited.

# The London Pioneers

The making of art pottery in Britain owes its main impetus to a number of unrelated events in London in the second half of the nineteenth century. In 1857 John Sparkes was appointed to take charge of the Lambeth School of Art. He felt that a school in a pottery district should make some artistic contribution to the local industry and he unsuccessfully tried to persuade Henry Doulton of the Lambeth Pottery to produce decorative wares in addition to domestic and sanitary stonewares.

Early in the 1860s William De Morgan first met William Morris at Red Lion Square and agreed to design stained glass and tiles for the firm of Morris, Marshall & Faulkner, but he soon broke away and started to decorate tiles on his own. He used a makeshift kiln set up in 1864 at the family home at 40 Fitzroy Square and allowed Sparkes to use it to fire tiles decorated by his students. Among the Lambeth students were two young sculptors, Wallace Martin and George Tinworth, who had been attending evening classes. In 1864 they went to the Royal Academy Schools and soon began to exhibit their work.

In the same year C. J. C. Bailey acquired the Fulham Pottery and decided to diversify its output by including decorative wares. Early in the 1870s he engaged Jean-Charles Cazin, formerly Director of the School of Art at Tours, to act as his chief designer. In 1872 Wallace Martin, after a period in a Devonshire pottery, joined the firm as a modeller and designer, working closely with Cazin.

Meanwhile John Sparkes had persuaded Henry Doulton to find a place for George Tinworth in his pottery. He was offered a job modelling medallions in terracotta and designing vases with incised decoration. Doulton's conversion to the idea of producing art pottery had begun.

In 1871 the Staffordshire firm of Minton set up an Art Pottery Studio at Kensington Gore to train young artists in the techniques of ceramic decoration.

By 1873 Wallace Martin had left the Fulham Pottery and set up on his own in the King's Road, taking three of his brothers, two of whom had been working at Doultons, into partnership. Thus, within the space of a few years, five centres in London were making or decorating art pottery.

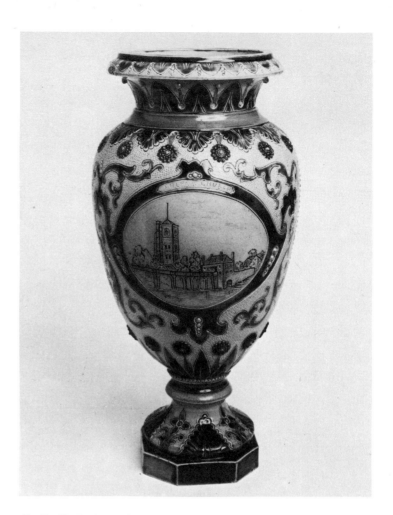

2. Fulham Pottery stoneware vase (1887) designed by J. B. Seddon with *sgraffito* decoration and brown and blue glazes painted by E. Bennett. Impressed marks: 'Fulham' and 'CJCB'. 21 cm. (Victoria & Albert Museum)

## C. J. C. Bailey & Co, Fulham Pottery

Fulham Pottery started to make decorative terracotta and stoneware with sgraffito designs in the 1860s and expanded their output in the 1870s after Cazin and Wallace Martin had been recruited. Nevertheless, the wares are not common. Signed pieces bear the names of E. Bennett, E. Kettle, R. W. Martin, and Bailey's own incised monogram. J. P. Seddon is known to have designed pottery, particularly jardinières. Incised or impressed marks include the name 'Bailey' with or without initials, followed by 'Fulham' or 'Fulham Pottery'. Bailey ceased to operate the works in 1889.

## William De Morgan

William Frend De Morgan was born in 1836 and educated at University College School and the Royal Academy Schools. He soon developed a feeling for design rather than painting and

3. De Morgan vase of Merton Abbey Period (1882–88) with stylised chrysanthemum in aubergine, shades of green, blue and turquoise, with base of purple scales. Finely crackled thick glaze. 26.6 cm. (Sotheby's)

this was greatly strengthened by his friendship with William Morris. Early experiments at Fitzroy Square included lustre decoration on tiles. In 1871 he moved to Cheyne Walk, Chelsea. From this time his activities fall naturally into three periods:

## The Chelsea Period, 1872–1881

De Morgan set up a small kiln at 30 Cheyne Walk where he was joined by Frank Iles who took charge of the firing. In 1873 he rented 36 Cheyne Walk which became the 'Orange House Pottery' with workshops and a showroom. The work was confined to decoration; biscuit tiles were bought from Poole in Dorset and shallow dishes and bowls from Staffordshire. De Morgan was fascinated by Greek, Etruscan, Moorish and Persian wares and their influence on his designs is evident. In the early days he favoured bird and animal motifs but as the business grew the range began to include stylised plants and flowers, and also sailing ships, lustred or enamelled in red, blue, and green in the 'Persian' style. His painters included Charles

and Fred Passenger, John and James Hersey and, perhaps the most skilful of them all, Joe Juster. Few of these early De Morgan wares are marked.

### The Merton Abbey Period, 1882–1888

In 1882 De Morgan built new workshops and a kiln on a site at Merton Abbey, Wimbledon, close to the chintz workshops of William Morris. He continued to live at Chelsea and retained his Orange House showroom. The tile business still flourished but the output of jugs, bowls and globular vases increased; some were still bought in the biscuit state but others which bear the Merton Abbey mark were made in the pottery. The strain of the daily journey from Chelsea to Wimbledon began to affect De Morgan's health but apart from moving his showroom to Great Marlborough Street in 1886 no changes were made until after his marriage to the artist Mary Evelyn Pickering in 1887.

4. De Morgan vase of early Fulham Period (1888–98) painted by Edward Porter in Isnik style with stylised flowers in clear turquoise, blue, green, slate and aubergine. 50 cm. (Sotheby's)

## The Early Fulham Period, 1888–1898

In 1888 De Morgan formed a partnership with a young architect, Halsey Ralph Ricardo. A new works was established at Fulham – the Sand's End Pottery. All the wares were made and decorated on the site. Vases were often in the 'Isnik' style, decorated with strong Persian colours – turquoise, green, blue and sometimes red (Fig 4), but the influence of *art nouveau* styles can sometimes be seen.

During the whole of this period De Morgan was closely associated with the Arts and Crafts movement, helping to arrange exhibitions and giving lectures. Sadly, his health failed to improve and he decided to spend the winters in Italy. He tried to direct the pottery from Florence, sending designs and advice. However, the management missed his dynamism. Ricardo was distracted by his commitments as an architect and standards began to fall. In 1898 the partnership ended, the Great Marlborough Street showrooms closed, and a new showroom was built at Sand's End.

## The Late Fulham Period, 1898–1907

After the break with Ricardo, De Morgan had to reorganise. He took into partnership three of the most devoted members of his staff, the artists Charles and Fred Passenger and his kiln

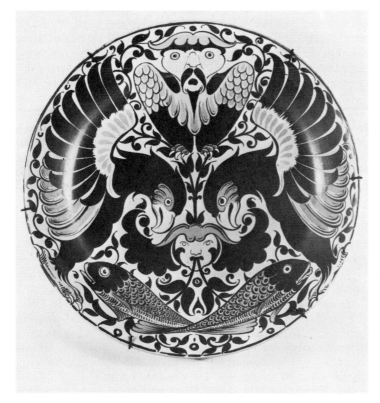

5. De Morgan dish of late Fulham Period (1898–1907) painted by Fred Passenger with opposed fishes and eagles, grotesque faces and foliage in pink and liver-red lustres. 36 cm. (Sotheby's)

7. Doulton lidded dish (1887) by Florence Barlow in green-and-white pâte-sur-pâte on a buff ground. Groups of three birds in flight and seven birds perched are entitled *Lucky Numbers*. Lambeth mark and artist's monogram with that of her assistant, Bessie Newbury. 21 cm

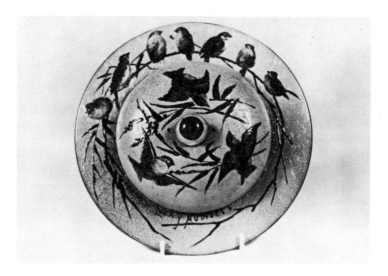

8. Doulton vase (1882) by Frank Butler with blue and brown stylised leaves on buff ground with dark-brown applied decoration. Assistants: Eliza L. Hubert, Isabella Miller and Annie Partridge. Lambeth mark and artists' monograms. 29 cm

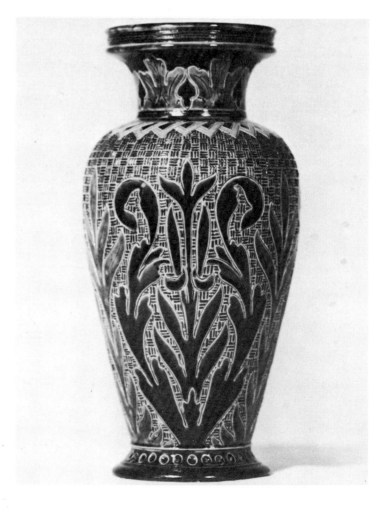

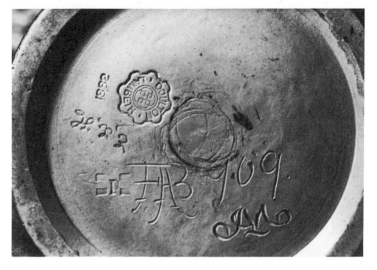

9. Base of vase (Fig 8) by Frank Butler showing impressed and incised marks

three assistant artists one of whom will have worked on the geometrical ground pressing tiny strips of clay to the surface with a seal. From about 1895 Butler's designs show the influence of *art nouveau*.

*Mark V. Marshall* was with the Martin Brothers at Southall before joining Doultons in 1880. It is hardly surprising that as a skilful modeller he followed Wallace Martin's example and made grotesques in his own idiom. Some were produced in numbers from moulds. A 'Borograve' vase in the form of a fabulous animal, half hedgehog, half fish, was inspired by Lewis Carroll's *Alice through the Looking Glass*.

*Eliza (Elise) Simmance* was at Doultons from 1873 to 1928 and over this period had a prodigious output. Her incised foliage designs are particularly good. In the 1890s she was influenced by *art nouveau* styles and used some designs by Charles Rennie Mackintosh.

*Emily E. Stormer* is sometimes confused with Eliza Simmance owing to the similarity of their monograms. However, she always used the three letters EES so there need be no confusion. Her incised decoration is particularly fine (Fig 10).

Many smaller pieces and some larger pieces with simple incised or applied work were often undertaken solely by assistant artists. The cruet (Fig 11) is a good example, executed by a team of three.

## Doulton Faience

Although Doulton stoneware is best known, the Victorian public appreciated the gay designs of Doulton faience. This was decorated by a separate group of artists, working from 1873. Among the best known were Mary Butterton, Mary Capes, John McLellan, Florence Lewis, Emily Robinson and Linnie Watt.

10. Doulton three-handled mug (1884) by Emily Stormer with an incised scroll pattern with brown, grey and dark-blue glazes. 15 cm

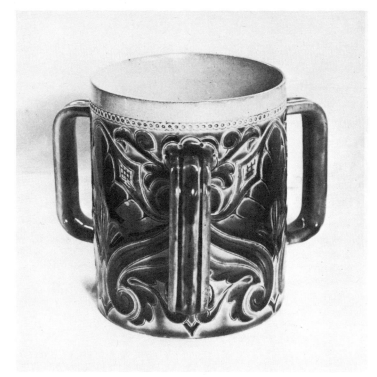

11. Doulton cruet (1879) in plated stand, with pots with incised decoration in blue and brown glazes, white beading on the salt and mustard pot. Decorated by three senior assistants – Harnett E. Hibbert, Louisa Wakely and Sarah P. Gathercole. Height to handle-top 15.5 cm

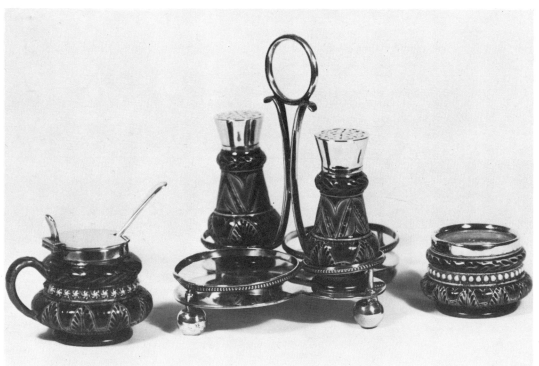

*Mary Butterton* worked at Doultons for twenty years. Highly regarded, she painted pieces for exhibition, including the Centennial Exhibition of 1876 in Philadelphia.

*Mary Capes* had a shorter career from 1876 to *c* 1883. Her work was described at the time by John Sparkes as 'inventive'. He stressed her willingness to experiment and to follow up the results 'in a truly scientific spirit'. The jug (Fig 12) shows the quality of her painting.

*John McLellan* joined the faience artists *c* 1880 and worked for some thirty years painting many of the larger pieces with scenes from fairy tales and nursery rhymes. Ladies with long hair and flowing garments in the *art nouveau* style were often used as decoration on tall vases.

*Florence Lewis* has been described as 'perhaps the most distinguished of the faience artists'. Her work shows good design and a fine choice of colours. She won many awards.

*Linnie Watt* joined Doultons in 1880 and left again in 1886 but her experience as a designer made a great contribution to the faience output. She specialised in painting plaques and dishes with scenes of children in the countryside.

Very good work was also done by some of the assistant artists. *Emily Robinson*, for example, painted the attractive little vase (Fig 13) with butterflies and berried sprays on a turquoise ground.

Doulton faience is by no means as common as the stoneware. The output was smaller and the product more fragile.

## Doulton bodies and styles

The 1880s saw many technical advances with new bodies and styles of decoration. They are listed below with the approximate dates of production:

*Impasto* (1880–1900) involved painting on unfired clay using thickened colour which left the pattern in slight relief.

*Silicon* (1880–1912) was a very hard smooth stoneware with a fine texture. It lent itself to many types of decoration including the application or inlay of coloured clays.

*Chine* (1885–1914), or Doulton and Slater's Patent, was a method of decoration in which lace was pressed on to the soft stoneware body before firing. Additional applied decoration was often added before glazing.

*Natural Foliage Ware* (1886–1914) was made by pressing leaves on the surface of the soft clay. The impressions were then linked by scratching lines to simulate stems, so forming sprays of leaves. These were then covered with a brown glaze (Fig 14).

*Carrara Ware* (1887–1897) was a type of dense white body made to look like marble. It could be modelled and was often painted by the faience artists.

*Marquetrie* (1887–1900) was made of sections of clay cut from pieces of different colour and shape built up to form a mosaic pattern. The name was also used for marbled pieces made from clays of different colours.

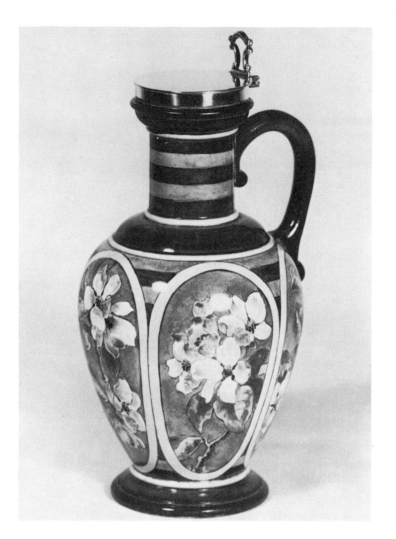

12. Doulton faience lidded jug (*c* 1880) by Mary Capes with reserves of pink and white apple blossom on olive-green ground, neck banded in brown and buff, shoulder and foot in dark blue. Plated lid. Impressed: DOULTON. Painted artist's monogram. 24 cm

*Crown Lambeth* (1891–1910) was a refined type of body made for the faience painters to enable them to use a greater range of colours.

In 1882 Doultons acquired the pottery of Pinder, Bourne & Co in Burslem, Staffordshire. Two young men were given responsible posts in the new venture – John C. Bailey as works manager and John Slater as art director. Artists from Lambeth helped to train the staff and art pottery was produced on a considerable scale but seldom reached the high standard of the earlier Lambeth wares.

In 1882, ten years after Doulton had appointed his first lady artist, the artists presented him with a document of appreciation. This contains the signatures and monograms of some 250 ladies and 20 men and is an invaluable source of information. The manuscript is reproduced in full in Richard Dennis's *Doulton Stoneware Pottery*.

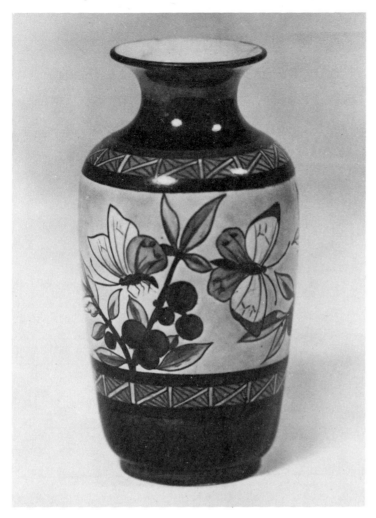

13. Doulton faience vase (*c* 1875–80) painted by Emily L. Robinson. Berried sprays and butterflies in browns and greens against an emerald ground. 11.8 cm

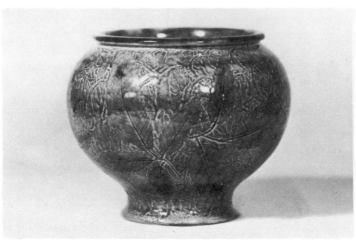

14. Doulton natural foliage plant-pot (*c* 1910). Rough ochre and sap-green ground impressed with leaves glazed reddish-brown. Royal Doulton impressed mark with crown and lion. Monogram of Lizzie French. 15.3 cm

### Doulton marks

Doulton wares are clearly marked and if they are not actually dated their period can be determined by the pottery marks.

| | |
|---|---|
| *c* 1867–77 | 'Doulton Lambeth' within an oval. |
| 1877–80 | 'Doulton Lambeth' impressed in a circle or printed within a circle. |
| 1880–1891 | 'Doulton Lambeth' within a rosette. |
| 1891–1902 | 'England' added to previous mark. |
| 1902–1922 | 'Royal Doulton England' in a circle surmounted by a crown and lion. After 1922 the crown was omitted. |

## The Martin Brothers

The production of 'Martinware' as it has come to be known was initiated by Robert Wallace Martin who, after working for some years as a sculptor, decided to concentrate on pottery. He spent some time in Staffordshire and Devon and then joined the Fulham Pottery of C. J. C. Bailey. Anxious to set up on his own, he established a workshop in 1873 at Pomona House, King's Road, Fulham in partnership with three brothers – Charles, Walter and Edwin Martin. Their wares were fired in the kiln at the Fulham Pottery.

The brothers formed an effective team with clearly defined functions. Wallace Martin, as founder, became the director and it was natural that, as a sculptor, he should specialise in the modelling of figures. Edwin Martin and Walter Martin had both worked at Doultons. Walter became the chief thrower, assumed control of the firing, and managed the kiln. He also experimented with colours. Edwin specialised in decoration and Charles looked after the business side. However, they all did some designing and decoration.

15. Martinware grotesques including a mask vase, a 'Wallybird', two spoon-warmers and a toast rack, all modelled before 1882. (From *The Magazine of Art* for 1882)

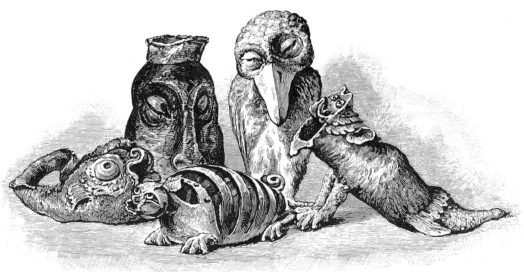

16. Martinware vase (1879) of pale-blue stoneware with *sgraffito* decoration showing a heron among reeds with dark-blue glaze outlines. Base has an olive-green glaze. Incised mark: *R. W. Martin London and Southall 6.5.79.* 27 cm.

Martinware is a salt-glazed stoneware, ideal for the style of decoration they used, for the glaze was so thin that it no way masked even the finest modelling. The pots were submitted to three days of intense heat before the salt was thrown into the kiln to produce the glaze. In the early days at least one-third of the pieces were ruined during firing. However, the brothers struggled on for four years, leasing a kiln at Shepherd's Bush when the Fulham kiln was no longer available.

In 1877 they found an old soapworks near the Grand Union Canal at Southall, Middlesex and converted it into a pottery, building a large kiln. In 1878 they were able to open a shop in Brownlow Street, off Holborn. Wallace Martin modelled many grotesques, possibly inspired by a number of casts of medieval carvings he had been shown by A. W. N. Pugin when he was employed on carvings at the new Palace of Westminster. These are now keenly sought after by collectors, especially the grotesque birds, sometimes called 'Wallybirds' after their

modeller (see Fig 15). Wallace produced grotesques for over thirty years.

The general wares of the Martin Brothers fall roughly into three main periods:

### First Period 1873–85

During this experimental period the brothers exploited the skills they had learned at Fulham and Doultons. Many of the wares are similar in style of decoration to Doulton wares. The incised vase dated 1879 (Fig 16) is very like the work of the Barlow sisters. However, as confidence grew they began to study museum pieces and to produce new shapes and styles.

### Second Period 1885–95

Simple rounded shapes began to appear with incised patterns often filled in with colour. Many are unique in style. Particularly fine decoration with fish begins to appear (Fig 17 *left*) and so does floral decoration (Fig 17 *right*).

### Third Period 1895–1914

Many gourd-shaped vases in the Japanese style were made with ribbed, inlaid and textured modelling (Fig 17 *centre*), including quite small pieces. Wallace Martin began to model mask jugs (Fig 18).

The decline of the Southall Pottery began in 1910 with the death of Charles Martin. Walter died two years later and production ceased. Collectors should know that Walter Martin's son, Clement, coloured and decorated some of the wares fired before the workshop closed, and later made some pottery which he called 'Martinware' in association with a Captain Butterfield who had previously worked for a time in the pottery. Fortunately, genuine Martinware is always clearly marked and dated. Between 1873 and 1883 it was incised *R. W. Martin* followed by *Fulham* if fired at the Fulham Pottery, *London* if fired at Shepherd's Bush, and *Southall* if made at their own works. From 1879 when the shop was operating the words *and London* were added to *Southall*. From 1883 the full mark was *R. W. Martin & Bros. London & Southall*.

## Minton's Art Pottery Studio

In 1869 the Minton firm of Stoke-on-Trent in Staffordshire invited W. S. Coleman, an established illustrator and watercolour artist already interested in ceramic painting, to exercise his skills on earthenware plaques. In 1871 they made him Art Director of a new 'London Art Pottery Studio' in Kensington Gore, established mainly for 'educated women of good social position' who could be employed 'without loss of dignity'. In all there were about twenty-five such ladies, all of whom had received some artistic training at London art schools. A few male decorators from Stoke-on-Trent acted as tutors and gave a professional atmosphere to the studio.

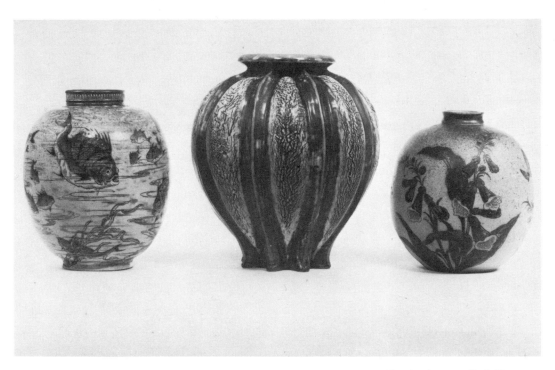

17.  Martinware. (*left*) Vase (1888) with incised spiny-backed fish, brown with blue touches, swimming among weeds. 20.2 cm. (*centre*) Gourd vase (1900) modelled with eight vertical bands green-glazed with brown edges, separated by areas patterned in green. 24 cm. (*right*) Vase with speckled ground engraved by Walter Whiley with foxgloves and insects in brown and dark-green. 17.7 cm. (Sotheby's)

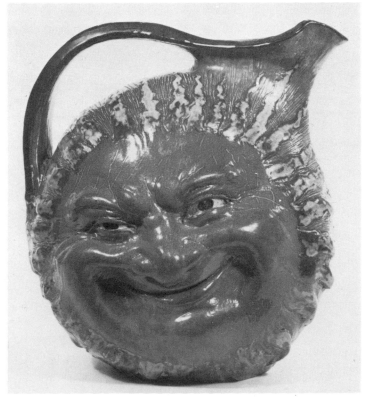

18.  Martinware mask jug (1897) moulded with a sunburst face smiling on each side, coloured in orange-red with the sun's rays in mottled copper-brown and straw; flat handle connects with pinched spout. 24 cm. (Sotheby's)

This was solely a decorating centre for biscuit wares from the Stoke factory but there was a local kiln – which used the engine-house chimney of the Royal Albert Hall as a smoke-vent. The venture was short-lived: Coleman left the studio in 1873 and in 1875 it was destroyed by fire. However, interesting plaques can sometimes be found with the printed mark 'Minton's Art Pottery Studio, Kensington Gore' within a circle. A few bear the signature of *W. S. Coleman*. His early pieces are painted in underglaze colours but later he painted on the glaze. H. Stacey Marks provided designs which were executed by artists who added their own monograms (Fig 19). Notable artists included Coleman's sisters – Helen Cordelia Coleman (Mrs Angell) and Rebecca Coleman. Hannah Barlow spent a short time in the studio before joining Doultons.

## Exhibitions at Howell & James

The presence of the Minton Art Pottery Studio in London helped to create a craze for amateur painting on pottery and porcelain. From 1876 the retail firm of Howell & James of 5–7 Regent Street, London held annual exhibitions for both amateur and professional painters, prizes being awarded to the amateurs. The circular plaque of a 'Winter Scene' (Figs 20 and 20a) was submitted in 1879.

19. Minton Art Studio plaque (1874), designed by H. Stacey Marks, one of a set of seven with figures in sixteenth-century dress illustrating the Seven Ages of Man. 25.5 by 51 cm. Artist's monogram and impressed MINTONS. (Sothebys)

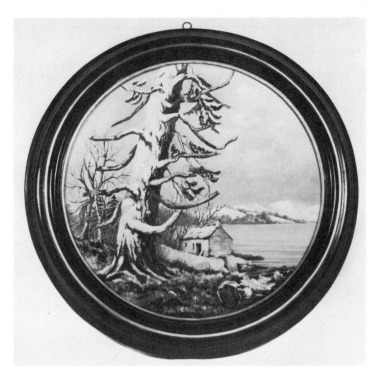

20. Plaque with 'Winter Scene'
painted by Mrs Nisbett, an
amateur entry for the Howell
& James' Art Pottery
Exhibition of 1879. 40 cm
(R. Clements)

20a. Label and rare Copeland
ceramic mark in red on reverse
side of plaque in Fig 20.

# Victorian Art Potteries outside London

A number of art potteries were established in the provinces, especially in the 1880s and some existing potteries started to produce art wares. Some are already well known but there is a wide field for research into the history of the others, some of which are mentioned in this chapter in the hope that further information may be forthcoming.

## The Ault Pottery, Swadlincote, Derbyshire

William Ault, born in Burslem in 1841, worked at a pottery in Church Gresley from 1863. In 1867 he left to train as an accountant and later returned to Church Gresley to manage a new pottery built by T. G. Green & Co. In 1883 he formed a partnership with Henry Tooth, formerly manager of the Linthorpe Pottery. Together they established the Bretby Art Pottery at Woodville in Derbyshire. The partnership ended in 1887, and Ault set up on his own at Swadlincote.

William Ault was clearly an admirer of the Linthorpe wares and although he had only a limited technical experience he persisted in experiments which led to the production of Ault Faience. He specialised in moulded plantpots and pedestals with fine coloured glazes but decorative vases were also made. These gained a considerable reputation; designs were provided by Christopher Dresser, some of which were used after Dresser's death in 1904 (Fig 21).

With the turn of the century the production of faience declined in favour of wares with *sgraffito* decoration, floral patterns with trade names, and wares with a black glaze decorated with small coloured figures.

Most of the wares carry a moulded mark with AULT on a ribbon beneath a reeded vase. The monogram AP was also used and pieces sometimes bear an impressed facsimile signature of Christopher Dresser. Ault's daughter, Clarissa, did some painting of flowers and butterflies and her initials C.J.A. are occasionally found on vases.

In 1922 the Ault Pottery absorbed the Ashby Potters' Guild (see p 65) and in 1923 became Ault & Tunnicliffe.

21. William Ault double-handled moulded vase (*c* 1900), after a design by Christopher Dresser; concentric star motif glazed bright green on brownish-green ground. Mark: a moulded vase and AULT. 18.5 cm

## Art Potteries of the Barnstaple Area, North Devon

Domestic pottery was made from local clays in North Devon in the reign of Queen Elizabeth. Towards the end of the seventeenth century decorative harvest jugs were made for local use and for export to North America. The red clay body of these jugs was covered with a fluid white slip which was then scratched with a design revealing the natural colour of the clay beneath. They were made at Barnstaple, Fremington and Bideford. Thomas Brannam, who operated two potteries at Barnstaple, exhibited harvest jugs at the Great Exhibition of 1851 and was awarded a bronze medal for *sgraffito* work. The art potters working in North Devon in late Victorian times had therefore a long tradition behind them. They included Charles Brannam, Alexander Lauder and William Baron at Barnstaple, and Edwin Beer Fishley and his grandson W. Fishley Holland at Fremington.

### C. H. Brannam's Litchdon Pottery

In 1879 James Brannam who had inherited the Litchdon Pottery in Barnstaple from his father, handed it over to his son

Charles Hubert Brannam who had been a student at the Barnstaple School of Art and was keen to produce art wares using traditional methods. The red clay came from Fremington and he soon started to use it to make small vases and jugs with *sgraffito* decoration. He threw most of the pots himself and concentrated on producing interesting shapes and devising attractive 'raw lead' glazes. The red body of the pots was covered with fluid slip, often coloured, and the design was then incised or carved in shallow relief, often in the form of panels separated by bold scrolls, each panel with stylised birds, fish or foliage against a stippled ground. In most cases the pattern was then picked out in colour by brushing on coloured slips, though this additional decoration was not used on Brannam's earliest pieces (Fig 22). Adopting the old Roman name for Barnstaple, he called his art pottery Barum Ware.

In 1882 Brannam recruited a skilled designer, John Dewdney, and by 1885 a second designer, William Baron. His art wares soon became well known largely as the result of publicity by Howell & James, the Regent Street dealers. By 1885 Barum

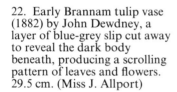

22. Early Brannam tulip vase (1882) by John Dewdney, a layer of blue-grey slip cut away to reveal the dark body beneath, producing a scrolling pattern of leaves and flowers. 29.5 cm. (Miss J. Allport)

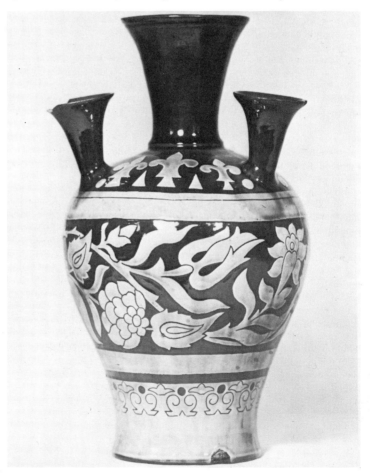

wares were being sold by Liberty's and in the same year were patronised by Queen Victoria: thereafter they became 'Royal Barum' wares. At this period the slips used for decoration tended to be relatively bright in colour, with brown, pale grey, red, white and yellow predominating. This continued until about the turn of the century. The large vase with dragon handles (Fig 23), for example, is dated 1900. After about 1895 darker colours began to creep in. The Diamond Jubilee mug of 1897 (Fig 24) has been covered with two layers of slip, first in yellow and then in a chocolate brown. The wording has been scratched through the dark slip to reveal the lighter layer below, and brushed-on slip in other colours completes the decoration. From this period many motto wares were produced.

In 1899 W. L. Baron left the pottery to set up on his own at Rolle Quay. However, his son Frederick Baron who had joined Brannam's two years earlier stayed on at least until 1910. The first decade of the twentieth century saw a change in the style of Barum wares. Blue became the most popular colour and plain undecorated dark-green glazes were used. New lines were in-

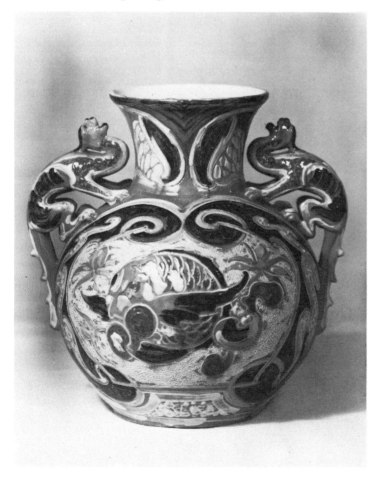

23. Brannam vase with dragon handles (1900) by Frederick Baron, incised and painted in coloured slips, mainly cream but with reserves of olive-green and brown fish touched up with blue and reddish-brown. 20 cm

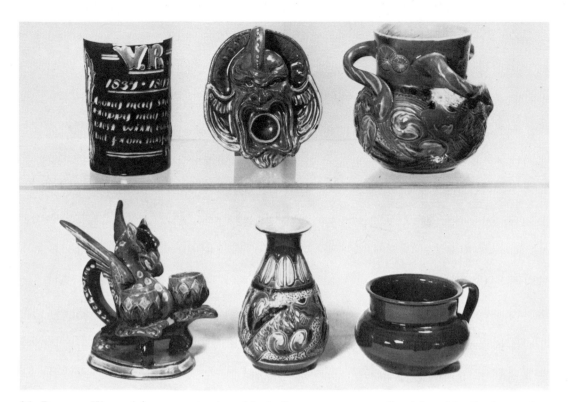

24. Brannam Wares. (*above, left to right*) Victoria Diamond Jubilee mug (1897) by Frederick Baron, covered with two layers of slip, an outer brown layer cut away to reveal a cream layer. 12 cm. Grotesque candleholder (1898) painted with brown and white slip on blue ground. Artist's initials – *BW*. Width 12 cm. Vase with swirling handles (1900) with incised and slip-painted fish decoration on green ground. 12 cm. (*below, left to right*) Grotesque candleholder (1901), decorated with applied blue, green and buff slips. Artist's initials – *RP*. 13 cm. Vase (1903) with incised fish motif touched with red, blue and brown slip. 13 cm. Handled vase (1913) with dark green glaze. 7 cm

troduced including grotesque candlesticks with slip decoration (Fig 24), and vases in the *art nouveau* style. Figures were also made (Fig 25).

Most of the Litchdon Pottery wares between 1879 and 1914 carry an incised or painted cursive signature – *C. H. Brannam*, the word *Barum* and often a date. From 1886 a registered mark appears near the base of most pieces, *Rd 44561*, protecting the trade mark of Barum Ware. Many pieces also bear the monogram of an artist or designer: *JD* for John Dewdney, *WB* for William Baron, *FB* for Frederick Baron, and *AB* for Arthur Braddon. Unidentified initials include *BW, RP, SW, VW*, and *WGC*. A few twentieth-century wares bear an impressed mark – C. H. BRANNAM BARUM N. DEVON. The addition of LTD to the mark indicates a date after 1914.

### Lauder & Smith's Pottington Pottery

In 1876 Lauder & Smith leased clay deposits at Pottington to the west of Barnstaple and set up a pottery to make bricks, tiles and architectural ornaments. Alexander Lauder was an architect with offices at 47 High Street, Barnstaple. In the mid-1880s he decided to start the manufacture of 'Devon Art Pottery'. By 1888 the firm had already opened showrooms at 71 High Street. The venture seems to have been entirely due to Lauder's enterprise; his name alone appears on the wares with the word *Barum*.

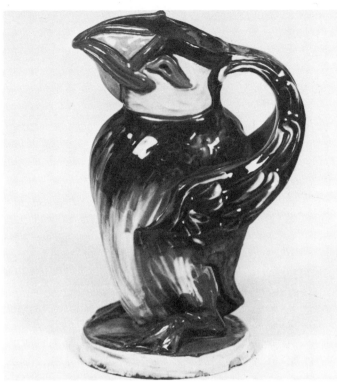

25. Brannam puffin jug (1900) with slip decoration in brown, yellow, green and blue. Incised mark and initials *PT*. 16.5 cm. (Mr and Mrs Derek Styles)

26. Lauder Wares. (*left*) Vase with swirling handles and flared rim (1880–1900), incised and carved decoration of leaves and fish painted with blue, green and red slips on dark-brown ground. 20.5 cm. (*centre*) Three-handled vase (1880–1900) with incised and carved Japanese-style decoration on stippled ground. 20.5 cm. (*right*) Vase with swirling handles and pinched rim (1880–1900) with fish design in incised grey slip, uncut areas a mottled green and blue. 12 cm

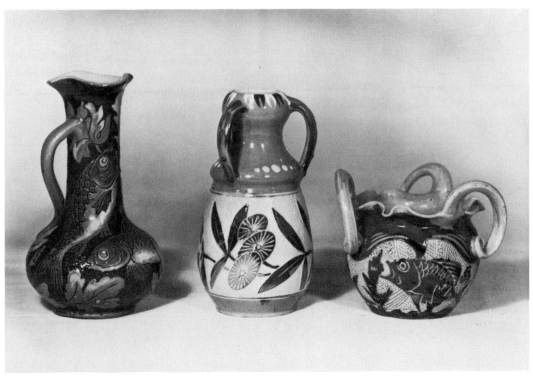

It is not easy to distinguish at a glance between Lauder and Brannam wares, for both used similar techniques. However, Lauder tried to 'follow nature' and his decoration tends to be more naturalistic. H. W. Strong watched a modeller at his stand in 1888. 'By the side of the pot which he is stippling we notice a little bramble bush and turning to the pot again we discover its counterpart in the dainty border of foliage he has modelled for the panel.' Fish provided a popular motif for both potteries which also favoured spiralling handles (Fig 26).

In addition to the incised mark *Lauder Barum* the wares normally carry a pattern or shape number. These reach well over 2000, a remarkably high number for a small pottery.

### Baron's Rolle Quay Art Pottery Works

William Leonard Baron established his pottery at Rolle Quay, Barnstaple, in 1899. He made motto wares, vases, plaques and figures, using a similar style to that employed when he worked at Brannam's (Fig 27). Early wares were incised *Baron Barnstaple* but after 1905 this was replaced by an impressed mark, BARON NORTH DEVON.

In 1902 Baron had showrooms at 59 Boutport Street and in 1910 at 'The Square', Barnstaple. By this time Frederick Baron had left Brannam's to take over the Rolle Quay works from his father. The pottery continued until Frederick Baron died in 1939 when it was acquired by Brannam's.

### Fremington Pottery

The Fremington Pottery, west of Barnstaple, was a family business inherited by Edwin Beer Fishley in 1865. The output included traditional harvest jugs. The glazes used were either yellow, made with red oxide of iron, or a brilliant green made with black oxide of iron. Beer Fishley's grandson, W. Fishley Holland, joined him in 1902 at the age of 13 and was soon making similar jugs. When the old man died his grandson continued the pottery for about a year and then moved to Braunton. Work there was interrupted by World War I but he returned and then, in 1921, moved to Somerset and established himself close to the Sunflower Pottery near Clevedon (see page 51).

Occasionally pieces may be found with the incised mark *E. B. Fishley, Fremington, North Devon*, or with the signature of William Fishley Holland – *W. F. Holland*, or the initials *WFH* or *FH*. Fishley Holland's autobiography *Fifty Years a Potter* (1958) gives a fascinating account of his work.

## Bishops Waltham Pottery

M. H. Blanchard, a sculptor and worker in terracotta, moved his works in the 1860s from Blackfriars Road in London to Bishops Waltham in Hampshire where a local clay was used to

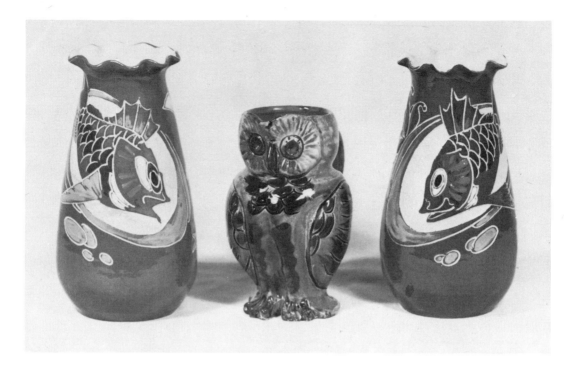

make architectural and garden ornaments. Early in 1867 he started to produce fine ornamental terracotta wares for interior use, especially jugs and vases, many decorated with classical scenes printed in black. They were of very high quality but were only made for about eighteen months and are therefore rare. The works closed in 1868. Bishops Waltham wares bear the printed mark BISHOPS WALTHAM within a two-line oval.

27. Baron Wares. (*left* and *right*) Pair of vases (*c* 1900–1910) with fish motifs incised and painted with coloured slips against blue ground. 13.5 cm. (*centre*) Owl jug (*c* 1900–1910) with modelled and incised decoration and bistre, blue, brown and green glazes. 10.3 cm. (Mr and Mrs Derek Styles)

## Bretby Art Pottery, Woodville, Derbyshire

Bretby Art Pottery was established in 1883 by William Ault and Henry Tooth who had been manager of the Linthorpe Pottery, Middlesbrough. In the early days the wares were similar in style to those of Linthorpe (Fig 28). Llewellyn Jewitt described the output in the first year as having 'a simplicity, even a severity, of form, a harmony of colouring, and a softness and delicacy of blending'. Well-glazed pieces in clear colours were made for some years but after 1887 many new lines were introduced. Ault had left the pottery and Tooth became wildly adventurous and produced unusual wares in great variety. Hand painting was introduced and decorative pieces were often gilded (Fig 29).

The Bretby Art Pottery followed these conventional wares with a whole series of unconventional designs, some frankly unworthy of the name of 'art pottery'. Moulded jardinières appeared in the shape of cabbages with the faces of girls peering from the leaves; cylindrical vases in the form of bamboo stems

28. Early Bretby vase
(*c* 1883–90) with ox-blood, pale
yellow and grey-green glazes
merging. Impressed mark:
BRETBY with rising sun.
12.4 cm

29. Bretby plant-pot (*c* 1895)
hand-painted in many colours
on bright yellow ground and
touched with gilt. Decoration
signed *AB*. Impressed mark:
BRETBY ENGLAND with
rising sun. 632H. 18.3 cm.
(Miss Jane Allport)

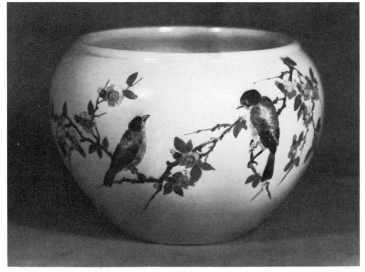

on a base supporting a stork; green-glazed dishes with biscuits or nuts moulded on the surface designed to fool the unsuspecting; pieces to represent natural wood *(Ligna Ware)*; and plaques and vases moulded in low relief with Japanese scenes (Fig 30), sometimes referred to as *Carved Bamboo*.

One of the most characteristic Bretby groups was designed to simulate metal. Some looked like copper *(Copperette Ware)*, some like cloisonné work. The influence of *art nouveau* was seen in jewelled ware in which the body was given a grey or dark brown glaze to simulate pewter or copper and was inset with ceramic 'jewels'. Another group, introduced in 1912, was given the name of *Clanta Ware* (Fig 31). Shapes were similar to those used for metal vases, and a matt bronze glaze to simulate metal was used.

The slip-cast electric lampstand of Sairey Gamp, probably made for the Dickens centenary of 1912, shows more artistic merit than many earlier Bretby pieces (Fig 32).

An impressed or printed mark of a rising sun above the word BRETBY was registered as a trade mark in 1884. After 1891 the word ENGLAND was added, and after 1901 MADE IN ENGLAND. Henry Tooth's initials sometimes appear on early pieces and the initials of various unknown artists have been recorded – AB, GB, AD, EM. It is known that William Metcalfe, previously at the Linthorpe Pottery, was employed as a decorator and that the owner's daughter, Florence Tooth, was a painter.

## Burmantofts Pottery, Leeds

From 1858 the Burmantofts Pottery in north-west Leeds was engaged in making bricks and pipes from local clays. The making of 'Yorkshire Art Pottery' started about 1880 when

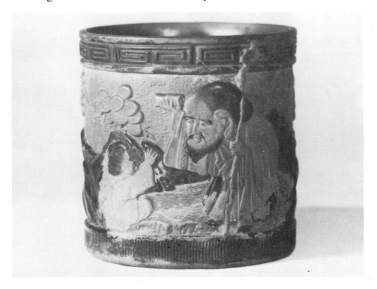

30. Bretby 'Carved Bamboo' plant-pot (*c* 1895), modelled in terracotta in low relief with a simulated Japanese design. Surface painted in matt black and buff, unglazed. Impressed mark: BRETBY ENGLAND 901 B. 20 cm

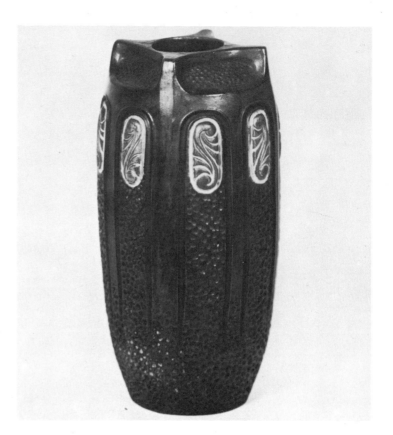

31. Bretby 'Clanta Ware' vase (*c* 1910–15), moulded with ribs and a pitted surface, and painted bronze to resemble metal; oval medallions painted yellow. Matt glaze. Impressed mark: CLANTA MADE IN ENGLAND 2346. 24 cm

the firm of Wilcock & Co Ltd started to make architectural terracotta.

Art wares included a wide range of vases, pot-pourris, rose-leaf bowls, comports and dessert services. The firm specialised in elaborately moulded jardinières and stands (Fig 33) decorated with translucent glazes, often in the *art nouveau* style. The Burmantofts works used many decorating techniques – modelling, painting, the application of coloured glazes and of coloured lustres. Early wares included small vases with long tapering necks decorated with bright glazes, especially of Persian blue, orange, yellow and sang-de-boeuf. A great variety of shapes included candlesticks (Fig 34) and ceramic clock cases.

The most notable product of the factory was painted faience. A hard earthenware was covered with a white feldspathic glaze, the decoration was painted on this surface in enamels, usually red, blue and green, and the whole was then covered with a clear glaze. The ovoid jar (Fig 35) is a typical example of Burmantofts faience painted in the style of William De Morgan. The jar is encircled by a dragon-like scaly creature in Persian blue with turquoise wings. The rest of the decoration consists of stylised flowers and leaves painted in yellows, browns and greens, outlined in black.

Although Burmantofts art pottery was exported to many

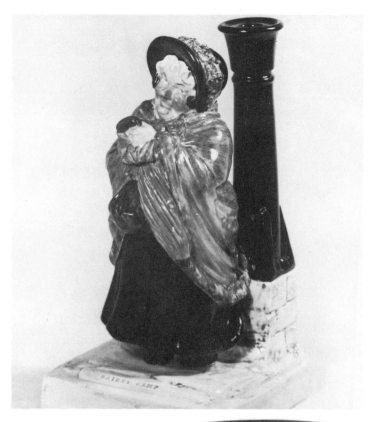

32. Bretby figure of Sairey
Gamp (*c* 1912), modelled as an
electric lamp holder and
painted in brown, orange,
purple and black. Impressed
mark: BRETBY ENGLAND
with rising sun. 21 cm

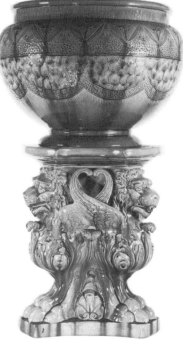

33. Burmantofts jardinière
and stand (*c* 1885), incised with
stiff leaves, tortoiseshell and
flames, the stand moulded as
three conjoined lions with
single paws and acanthus-leaf
bodies; the whole under a
brilliant turquoise-blue glaze.
Impressed mark. 87.5 cm.
(Sotheby's)

35. Burmantofts ovoid faience vase (*c* 1885–90) enamelled with a winged-dragon design in deep-blue, turquoise, green, brown and yellow. For marks see Fig 36. 22.5 cm

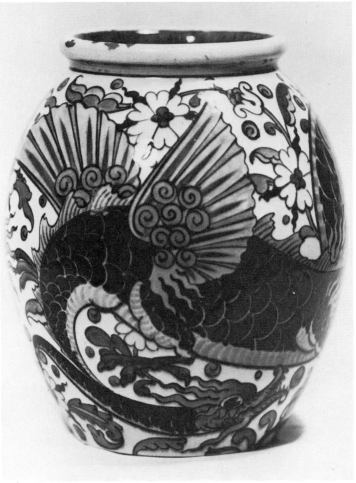

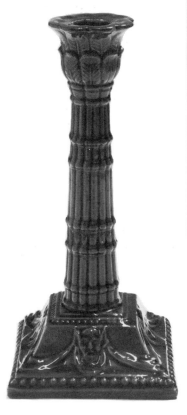

34. One of a pair of Burmantofts candlesticks (*c* 1880–90) moulded in relief and covered with a dark-brown glaze. Impressed marks: BF and 1830. 20.5 cm

countries, economic conditions after 1900 reduced the margin of profit and in 1904 it was no longer made though architectural faience and terracotta were produced until 1914.

Little is known about the Burmantofts artists and designers, though many pieces carry painted monograms (Fig 36). Esther Ferry and Rachel Smith joined the staff from Linthorpe and Rowland Charles Brown and Harold Leech must have been key workers for they were experienced enough in 1890 to start the Leeds Art Pottery which operated for nearly ten years making similar wares, marked either LAP LEEDS or LEEDS AP. In 1893 a breakaway group from this pottery, headed by James W. Senior, established Woodlesford Art Pottery, a few miles south-east of Leeds, which lasted for three years. Both these potteries derived styles and techniques from Burmantofts but attribution is usually easy since nearly all Burmantofts wares bear the firm's mark, BURMANTOFTS FAIENCE, or a monogram based on the initial letters.

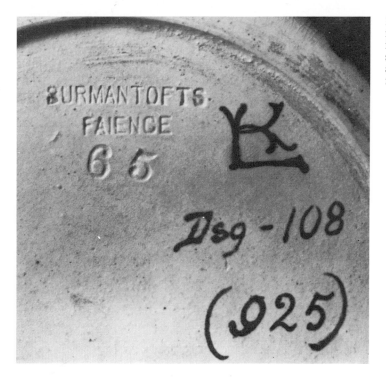

36. Typical Burmantofts marks on vase (Fig 35) include impressed factory mark and shape number 65, painted artist's monogram, design number, etc

## Carter & Co of East Quay, Poole, Dorset

The area around Poole Harbour in Dorset has deposits of ball clay which were used in the nineteenth century by several potteries to make architectural wares and mosaic tiles. The Patent Architectural Pottery Co at Hamworthy was probably the largest. In the 1860s James Walker, one of its chief technicians, set up his own works at East Quay, Poole and in 1873 sold it to Jesse Carter. By the 1880s the firm of Carter & Co had become noted for murals. By this time two sons, Owen and Charles had joined the business.

As early as 1880 a little art pottery was being produced. In due course expansion of this side of the business became possible with the absorption of the Hamworthy works of the Architectural Pottery Co.

### First Period Poole Pottery, *c* 1880 – *c* 1921

Under the technical and artistic direction of Owen Carter, staff were recruited locally and from Staffordshire. Embossed pots were made with raised floral decoration, wares with coloured glazes, and some lustre wares in the *art nouveau* style. The most typical pottery, however, had a buff vitreous body covered with a thick grey or cream-coloured slip painted with bands of geometric design (Fig 37).

Owen Carter knew William De Morgan to whom biscuit wares were supplied, and was friendly with the Burton brothers

43

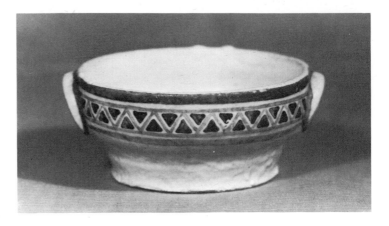

37. Two-handled bowl (*c* 1900) by Carter & Co of Poole with a thick cream-coloured glaze painted in green and black with a geometrical design. 5.3 cm

of Pilkington's. With a decrease in the demand for tiles after the outbreak of World War I he decided to step up the ouput of art pottery. Radley Young, the chief thrower, was put in charge of craft pottery, and young women artists were trained, including Lily Gilham who had done some modelling in clay, and her sister Gertie Gilham.

During the war Carter became friendly with Roger Fry, an artist who had founded the Omega Workshops in London. Fry visited Poole and there is no doubt he influenced the style of the wares and helped to make them more popular in London. They were now stocked by Heals and Libertys as 'Poole Pottery'. In 1919 Owen Carter died suddenly. Within two years the first period at Poole may be said to have ended. A new era had begun (see p 85).

First Period Poole pottery is not common. Pieces are usually marked with an incised *Carter Poole*, sometimes with a date.

## Castle Hedingham Art Pottery

Edward Bingham had a pottery at Castle Hedingham making domestic earthenwares from 1837. His son, also named Edward, helped his father at an early age but longed to make decorative wares. As there was little market he became a shoemaker, spending his spare time in the pottery. His first success came in the 1870s when his work was seen at public exhibitions at Hertford, Sudbury and Chelmsford. In 1876 he became a full-time potter, reviving the old pottery which had been in disuse since the death of his father in 1872. He made *Hedingham Ware*. His pots were unique. Some were decorated in relief with scenes from Roman history (Fig 38); others were made in the Elizabethan style with fictitious dates, though they were not intended to deceive since they carried the Castle Hedingham mark. Most pieces were made in unglazed terracotta, grey in colour, but a few glazed wares were made, including copies of Palissy wares and some plates, jugs and mugs commissioned as marriage gifts.

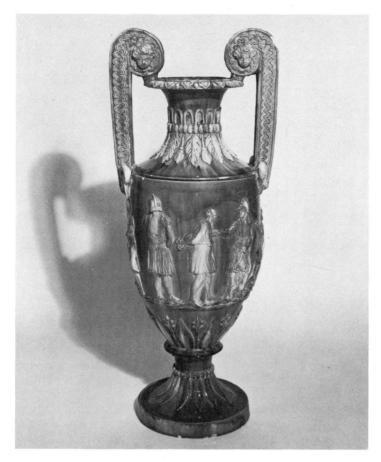

38. Castle Hedingham
Exhibition vase (1889) with
grey body and light clay relief
mouldings, blue-glazed overall,
depicting a captive with two
Roman soldiers. Incised mark:
*E. Bingham Castle Hedingham
Essex 1889.* 77.5 cm.
(Colchester and Essex
Museum)

For ten years the business prospered and Bingham's two
sons, Edward and Richard, worked in the pottery. Richard
made small pieces collectively known as *Gem Ware* which could
be used to decorate what-nots, ledges and window sills. In the
late 1880s the pottery declined and in 1888 Richard left for
America. In 1899 when Edward Bingham reached the age of
seventy, his son Edward took over the pottery but he had little
head for business and in 1901 sold out to a firm which renamed
it the Essex Art Pottery. He became the manager but only for
four years. In 1905 the works closed.

The Binghams used many different marks. The most typical
is a towered castle applied to the base of the wares together with
the name *Bingham*. Occasionally the words *Castle Hedingham*
appear. After 1901 marks include the words *Essex Art Pottery*
or *East Anglian Pottery*. Occasionally pieces may be found with
the marks chipped away. This has been done by some dishonest
vendor to suggest that the piece has an earlier date.

A full account of the Castle Hedingham Pottery is contained
in two articles by R. J. Bradley in *The Connoisseur* for March
and April 1968.

## Commondale Pottery, North Riding of Yorkshire

In 1872 John Crossley reopened an old pottery in the Cleveland Hills about 4½ miles south-east of Guisborough and named it after the nearby village of Commondale. After some years he began to produce art pottery, fine smooth terracotta wares of an apricot colour, made from local clay. They were mainly vases, finely turned and decorated with thin bands of colour, usually light blue or dark brown, and often with bands of white beading (Fig 39). Art pottery was certainly made before 1880, when the firm produced a centenary mug to celebrate the opening of the first Sunday School by Robert Raikes in 1780.

It was difficult to keep skilled labour in such a remote area and the making of art pottery ceased in 1884. These wares, which bear an impressed mark COMMONDALE POTTERY printed in a circle, are rare.

39. Commondale terracotta vase (*c* 1880–84) of peach colour with turned decoration and white beading. Impressed mark: COMMONDALE POTTERY printed in a circle

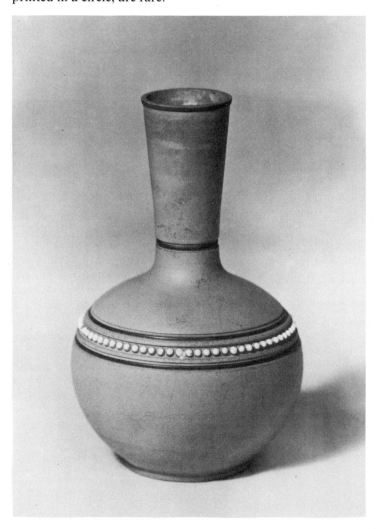

# Compton Pottery, Guildford

Mary Seton Watts, the wife of the noted Victorian painter G. F. Watts, started a school of decorative terracotta work to train recruits from the village of Compton with the idea of building a cemetery chapel. This was completed in 1896 but the making of terracotta in the Compton Pottery continued. In 1903 Mrs Watts formed the Potters' Art Guild. Apart from terracotta, some beautifully modelled figures were produced, mainly of saints. These were sold in hand-made fumed-oak boxes, mainly to Catholic communities. Some were modelled by Tom H. Wren who had been assistant to G. F. Watts. Other modellers included George Alberton and Lincoln Holland. The figures were painted in tempera and unglazed. A paper was affixed to the base of each with the instruction: 'To clean or polish use a hand brush. Do not wash.'

In 1922 a fire damaged the pottery and it had to be re-constructed. In 1938 the Potters' Art Guild took over the management and when the local clay was worked out took to slip-moulding. Unfired colours were still used and standards declined. Bookends in the form of busts, for example, have little artistic merit. The pottery closed in 1956.

Compton wares, hard to find in good condition, bear the mark COMPTON POTTERY GUILDFORD within an oval.

# Craven Dunnill & Co Ltd, Jackfield, Shropshire

Craven Dunnill operated from 1872 as a tile works, and supplied William De Morgan with blanks for decoration. There was a small output of art pottery including gold lustre wares but pieces are rare. The impressed mark shows a view of the pottery kilns with the letters C D J.

# Cumnock Pottery, Ayrshire, Scotland

The Cumnock Pottery existed in the eighteenth century. The making of Scottish motto wares of local red clay was well established in the second half of the nineteenth century when it was run by the Nicol family. The clay body was partly covered with yellow slip and a Scottish saying was scratched through this layer (Fig 40). These motto wares were not only sold locally but were also exported, no doubt to Scots overseas. The pottery closed in 1907 though retail sales continued for some time.

# Della Robbia Pottery, Birkenhead, Cheshire

The Della Robbia Pottery at Birkenhead was started in 1894 by Harold Rathbone and the sculptor, Conrad Dressler. Rathbone had been greatly impressed by the fine panels, reliefs and fountains created in Florence by the family of the sculptor Luca della Robbia. He particularly admired their use of vitrified lead

40. Lidded jam pot (*c* 1890) by Cumnock Pottery of dark-red clay body, the Scottish motto scratched through a layer of yellow slip. 11.7 cm. (Professor J. S. A. Spreull)

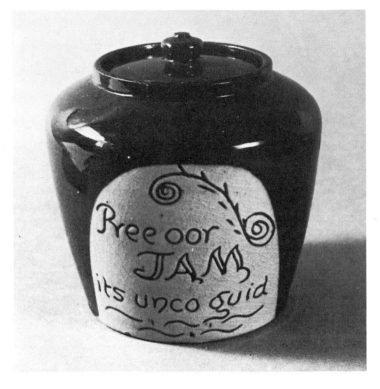

41. Della Robbia cylindrical vase (1900) with flared rim. *Sgraffito* and painted decoration by Liza Wilkins using olive-green and yellow enamels and green glaze. (For marks see Fig 43.) 40 cm

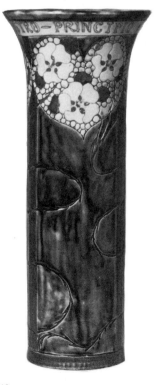

glazes on sculptured terracotta and he tried to emulate their work, naming his pottery Della Robbia.

The making of art pottery began on a small scale and expanded after 1898 when Carlo Manzoni, an Italian sculptor who had been running the small Granville Pottery in Hanley, became Rathbone's associate. The pottery received wholehearted encouragement from many of the best artists of the day – Walter Crane, Lawrence Alma-Tadema, Holman Hunt, G. F. Watts and, in the last two years of their lives, Lord Leighton and William Morris. The Della Robbia philosophy is summed up in the inscription on the cylindrical vase (Fig 41) – *Amore sia il nostro principio*.

Rathbone not only directed artistic activities but also took an active part in modelling and designing. He attracted a number of notable artists as designers, including R. Anning Bell, and many students were recruited from the art schools until a peak output was reached between 1900 and 1903. Decorators were encouraged to experiment with their own patterns and colours. However, economic conditions caused the closure of the pottery in 1906.

Ornamental wares included vases, plaques and dishes, rose bowls and inkstands, mainly decorated with *sgraffito* and coloured enamels in imitation of Italian *maiolica*. The wares have a brown clay body covered with a thin layer of white or cream-coloured slip. The decorators scratched through the masking

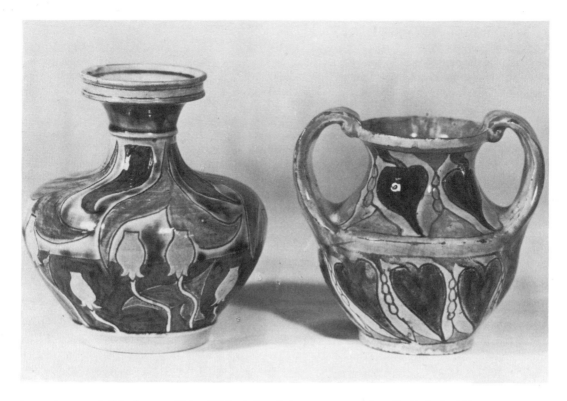

layer to reveal thin brown lines. This defined the pattern and raised tiny walls of clay to contain the applied enamels and glazes. The vase (Fig 41) decorated by Liza Wilkins in 1900 illustrates the technique. The *art nouveau* design and lettering have been scratched through slip and the colouring has then been carried out in stages. The reserves of flowers have been painted with yellow and olive-green enamels and the same green has been used on narrow vertical bands. The wider spaces between these bands have then been filled in with an emerald-green glaze which has been allowed to run to produce a mottled effect. The two vases (Fig 42) of the same period have been decorated in the same way.

The artists responsible for decoration incised their initials and usually the date on the base of the vase or dish. Well known Della Robbia artists include:

RB — Ruth Bare, noted for her modelling. Her initials have been noted on a fine two-handled jar decorated in yellow, green and brown with the modelled heads of three girls with swirling straw-coloured hair flowing in *art nouveau* style. It carries the date 1903 and both incised and painted initials indicate her responsibility for both modelling and painting.

C — This is usually assumed to be Charles Collis who worked as a decorator during the whole period of art pottery production.

42. Della Robbia vases decorated with *sgraffito*, enamels and coloured glazes. (*left*) Vase (*c* 1900) with brown and olive-green enamels and green and yellow glazes. Artist's initials A.C. Undated. 13 cm. (*right*) Two-handled vase (1901) with olive-green, turquoise and buff glazes. 10.5 cm. Initials E.T.

43. Base of Della Robbia vase (Fig 41) showing typical marks – an incised ship with D R for Della Robbia, the date 1900, and *LW*, the initials of the artist Liza Wilkins

49

JH       – James Hughes, who worked as a painter from 1895.
CM       – Carlo Manzoni.
R        – Usually assumed to be Harold Rathbone.
CAW      – Casandia Ann Walker.
EMW      – E. M. Wood.
LW       – Liza Wilkins, who was with Della Robbia through-
           out the life of the pottery.
VW       – Violet Woodhouse.

Initials of unidentified artists include AC (see Fig 42 *left*); J; FM; ET (see Fig 42 *right*); and W. The artist's marks usually appear below the incised pottery mark, a ship with sail and pennant flanked by the letters DR for Della Robbia (Fig 43).

## Dunmore Pottery, Stirlingshire, Scotland

Dunmore Pottery was close to the River Forth, about a mile from the village of Dunmore. It originally made domestic wares but in 1860 was acquired by Peter Gardiner, a native of Alloa. He used the local red clay to make ornamental vases, figures, Bacchanalian jugs, baskets, little pottery hens, dogs, fish and even teapots in the form of tortoises. These are all remarkable for their fine coloured glazes including orange, brown, cobalt-blue, copper-green, and crimson. Sometimes several colours were splashed on the surface. Typical Dunmore vases (Fig 44)

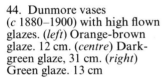

44. Dunmore vases (*c* 1880–1900) with high flown glazes. (*left*) Orange-brown glaze. 12 cm. (*centre*) Dark-green glaze, 31 cm. (*right*) Green glaze. 13 cm

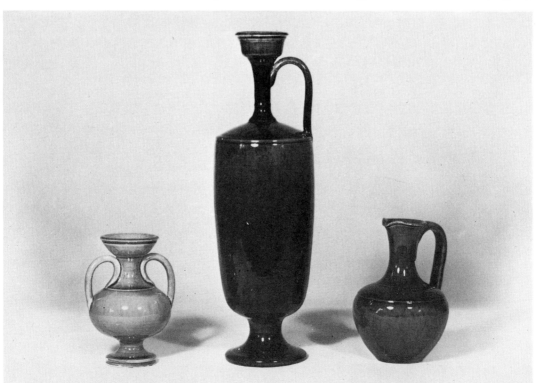

have simple classical shapes and are glazed with a single colour which has been allowed to run, giving a subtle impression of light and shade.

Moulded leaf plates, comports (Fig 45) and baskets were made, the latter with handles woven from strands of clay pressed through a 'squeeze-box'.

Gardiner owed a great deal to the Countess of Dunmore who succeeded in interesting London china dealers in his pottery. She also arranged for the Prince of Wales to visit his works in 1871.

Peter Gardiner retired in 1903 and for some years the work was carried on by the Dunmore Pottery Company, finally closing *c* 1911. Dunmore marks are impressed; they include the word DUNMORE, sometimes with the name of PETER GARDINER.

## Elton's Sunflower Pottery, Clevedon

In 1879 Sir Edmund Elton established a pottery at Clevedon Court in Somerset using the clay from his estate. This came to be known as the Sunflower Pottery. Sir Edmund was a designer and was fortunate to recognize the artistic and practical ability of George Masters, one of his staff, who learnt to throw pots and the techniques of decoration. Sir Edmund was inventive.

45. Dunmore comport (*c* 1880–1900) moulded with a stem in the form of dolphins with tails entwined on triangular base, the whole with flowing brown and green glazes. 19.5 cm. Impressed mark. (Huntly House Museum, Edinburgh)

He designed a unique wheel which made it possible to lift a pot while still attached to the board, a great advantage for the decorative methods he used. Pots were allowed to harden and then drawings of flowers such as chrysanthemums, daisies or sunflowers were transferred to the surface and the design then indented with a special blunt tool. The board with the pot still attached was then inverted and coloured slip, usually of a dark blue or green, was poured over it. Other colours were then splashed on to produce a marbled appearance. The design was then raised by brushing on a thick slip before firing. The last stage was the application of a clear translucent glaze.

Although flower-decorated vases (Fig 46) were the stock in trade, Elton also produced lustre wares with crackled metallic glazes. His work was widely exhibited and although he potted mainly for pleasure he sold many decorative pieces, some to America, Tiffany acting as his agent. He was a perfectionist and any pot that did not reach his standard would be thrown against a wall. Nevertheless, it is thought by some that the handles on mugs and jugs tend to be too heavy. This is because the clay was never pulled. It was rolled out, bent and fixed by adding more clay at the joints.

Sir Edmund Elton died in 1920. Thereafter, Sir Ambrose Elton carried on the pottery with help from W. Fishley Holland (see p 36), until 1930.

Elton pottery has the word *Elton* painted or incised (Fig 47), occasionally with a date. A cross was added to the mark after 1920.

## The Gateshead Art Pottery, Durham

The Gateshead Art Pottery is mentioned in a directory of 1884 as situated in East Street, Gateshead. A single piece has been

46. Elton vase and jug (*c* 1890–1900) covered with dark-blue slip splashed with yellow, light-blue, purple and dark-brown slip and with a floral pâte-sur-pâte decoration, the whole with a brilliant clear glaze. 20 cm and 14.6 cm

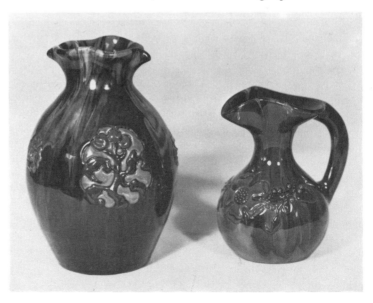

noted of the faience type (Fig 48), the red body covered with an opaque white glaze. This shallow decorative plate or plaque has a rectangular reserve painted with a scene in the Japanese style. On the base is the name of the maker boldly painted in cursive letters – *The Gateshead Art Pottery*, and a mark with a printed letter B enclosing the letters S and C could be the monogram of the artist or the initials of the firm. If the latter, could this be a member of the Burns family, well known as Gateshead potters in the nineteenth century?

## Kirkcaldy Pottery, Fifeshire, Scotland

The Kirkcaldy Pottery was run by the Methven family and then by the family of the works manager Andrew Ramsey Young, though the firm was still known as D. Methven & Sons. At first a local clay was used but this was later replaced by imported clay from Cornwall. Early in the 1920s Jessie M. King was commissioned to paint some of the wares on the biscuit before firing. She was a well-known book illustrator and her designs on the pottery were mainly derived from fairy tales such as *The Blue Bird*. (See 'Studio Talk' in *The Studio* for 15 May 1922.)

## Kirkby Lonsdale Pottery, Westmorland

John Thomas Firth operated a small family pottery from about 1892 to 1904 at Mill Brow, Kirkby Lonsdale where by chance he produced a glazed vitreous black ware which was noticed as an important discovery by the artistic journals of the day. He was friendly with William and Joseph Burton and some of his early pots were fired at Pilkington's works before he built a kiln of his own. Much of the decoration was in *sgraffito* style.

47. Base of Elton jug (Fig 46) showing typical *Elton* painted mark and the circular pad marks made by the blobs of clay used instead of stilts when the glazed pots were fired

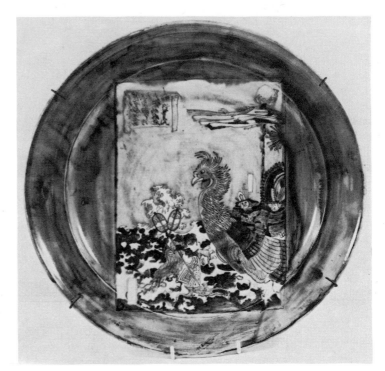

48. Gateshead Art Pottery dish (*c* 1885) with oriental scene enamelled in brown, red, yellow, turquoise and indigo blue on a rectangular reserve, the border with a flown olive-green glaze. Painted mark: *The Gateshead Art Pottery* and monograms involving the letters *SCB* and *ISC*. 34 cm. (Mrs K. A. R. Coleman)

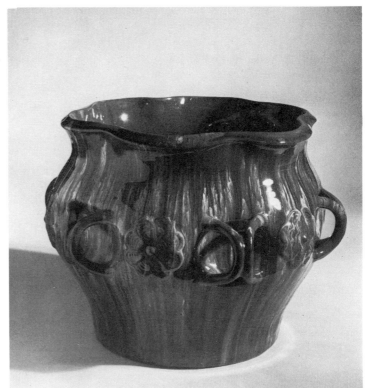

49. Linthorpe plant-pot (*c* 1885) with foliate rim and double loop handles applied in a row alternating with flower-heads, the whole with a brown glaze streaked with cream. Impressed mark: LINTHORPE 534. 21 cm

54

Firth signed the pots with his scratched initials *JTF* and with *KL* for Kirkby Lonsdale. His son Sidney signed his *SF* and his daughter Ellen used *EF*. The wares are uncommon.

## Linthorpe Pottery, Middlesbrough, Yorkshire

The Linthorpe Pottery at Middlesbrough resulted from a meeting between Dr Christopher Dresser and John Harrison who owned part of the Linthorpe estate. Dresser had noted the presence of a red clay and suggested to Harrison that a pottery might provide useful employment to alleviate local distress. Harrison built a pottery with a gas-fired kiln in 1879. Henry Tooth, an artist from the Isle of Wight, was appointed manager after spending some time in the Potteries studying ceramic methods. Dr Dresser agreed to serve as art director for three years. The designs of the pottery reflect his interests. He had spent some time in Japan and also had a feeling for the primitive arts of Colombia, Mexico and Peru. The early output at Linthorpe shows Japanese and South American influences, especially in design. Many pieces bear Dresser's signature.

The Linthorpe Pottery soon became noted for fine glazes in soft greens, yellows, greys, reds and purple. At the Society of Arts Exhibition of Modern English Pottery in 1882 critics praised their 'extraordinary range of beauty and brilliance'.

50. Linthorpe posy bowl (*c* 1885) with folded rim and underglaze floral decoration in green, white and yellow on dark-brown ground splashed with green and white. Impressed mark: LINTHORPE 274. 5.7 cm

In 1882 Henry Tooth was succeeded as manager by Richard W. Patey who had come with him from the Isle of Wight. At this stage white clay was imported from Cornwall and more conventional shapes were introduced. There was also an increase in the amount of painted decoration undertaken by young ladies under a supervisor, Lucy Worth. Sprays of flowers or birds were particularly favoured.

Linthorpe wares sometimes have the name or initials of the artist painted, impressed or incised. J. R. A. Le Vine in a Teesside Museums booklet (1970) on *Linthorpe Pottery* has noted the following: Alec Burns; Fred Brown; James Dunning; William Davison; Arthur Fuller; D. Hart; A. Lang; William Sheldon Longbottom; William Metcalf; Florence Emma Minto; E. Phillips; Arthur Pascal Shorter; Rachel Smith; Annie Umpleby; Lucy Worth; Joseph Wright.

The impressed mark LINTHORPE in various forms was used throughout the life of the factory. Impressed mould numbers are to be found on most wares.

Unfortunately John Harrison's other interests failed in 1889; he became bankrupt and the pottery closed. Several of the staff moved to the Burmantofts Pottery at Leeds.

## Maw & Co, Broseley, Shropshire

Maw & Co established a pottery in Shropshire in 1851 to make tiles and mosaics. The techniques developed proved suitable for use on art pottery and, in order to expand, the works was entirely rebuilt in 1882–3. The early art wares were mainly vases in majolica decorated with motifs in low relief. Later they invited Walter Crane and Lewis Day, both founder members of the Arts and Crafts Exhibition Society, to design tiles for them.

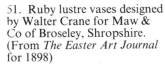

51. Ruby lustre vases designed by Walter Crane for Maw & Co of Broseley, Shropshire. (From *The Easter Art Journal* for 1898)

Walter Crane also designed some vases which were decorated with a fine ruby lustre (Fig 51). Most of the designs show figures, often with flowing robes, but a few depict sailing ships with high prows. Crane declared: 'I designed a set of vases for lustre ware, giving the sections for the thrower, and painting on the biscuit the designs, which were copied on duplicate vases in lustre.' These vases, made in the late 1880s, are undoubtedly the finest pieces from the Maw Pottery.

All marks, impressed or printed, include the name MAW or MAW & CO., usually with the locality BROSELEY, and sometimes with the county name SALOP or SALOPIA.

## Rye Pottery, Sussex

The Cadborough Pottery, near Rye, was operated from about 1840 by the Mitchell family and it was here that Frederick Mitchell started to make art pottery. In 1869 he established the Bellevue Pottery and in 1871 the Cadborough works closed.

Two special lines were produced at Bellevue: *Sussex Ware*, decorated with mottled coloured glazes on a brown body (Fig 52), and *Sussex Rustic Ware* with a dark-brown tortoiseshell finish and applied decoration, usually in the form of moulded hops and hop leaves in natural colours. Handles were usually made from twisted strips of clay. Miniature rustic wares were also made, pseudo-Palissy dishes, and some lustred pieces.

Rye pottery marks may be impressed or incised. They include *Sussex Ware*, or SRW Rye arranged around two intersecting lines (SRW stands for Sussex Rustic Ware). After about 1920 the SRW was replaced by SAW (Sussex Art Ware). The works closed with the outbreak of war, from 1939 to 1947. For a full account see *Victorian Art Pottery* by E. Lloyd Thomas.

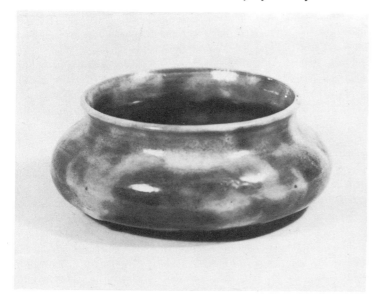

52. Sussex Ware bowl (*c* 1880–1900) with turquoise and brownish-green mottled glazes. Incised mark: *Sussex Ware Rye*. 5.3 cm

# Art Potteries of the Torquay Area, South Devon

Art potteries were established in South Devon in the second half of the nineteenth century on a belt of fine red clay discovered in the Torquay area. It was free from grit and produced a smooth matt surface ideal for terracotta wares.

### The Watcombe Pottery

The Watcombe Terracotta Clay Company established a pottery at St Mary Church in 1869 to make 'art manufactures'. An experienced art director, Charles Brock, was appointed manager and skilled workers were recruited from Staffordshire. By 1877 there were over 100 employees. Much of the output was for outdoor use but jugs, spill vases, candlesticks, tobacco jars, teapots and cream jugs (glazed inside), and small busts may be found though they are not common.

Decoration included *sgraffito* work, the use of enamels (particularly a turquoise blue), and engine-turning. Some classical vases have Etruscan-style decoration in black. The firm employed a number of sculptors to work on statuettes and busts. The bust of Gladstone (Fig 53), dated 1884, a copyright and limited edition, carries the name of Albert Bruce Joy, Sculptor.

Watcombe pottery was noted for its terracotta plaques, made in a pale pink colour by mixing local red clay with a white clay from Heathfield, near Newton Abbot. These were sold mainly as blanks to be decorated by the purchaser, so inevitably the quality of decoration on them varies greatly. Most examples are in colour but occasionally they may be seen with black pen-and-

53. South Devon Terracotta Wares (1880–1900). (*left*) Engine-turned jug attributed to the Torquay Terracotta Company. 14.5 cm. (*centre*) Watcombe Pottery plaque with black pen-and-ink drawing. 21 cm. (*right*) Watcombe Pottery bust of William Gladstone by A. Bruce Joy. 14.3 cm

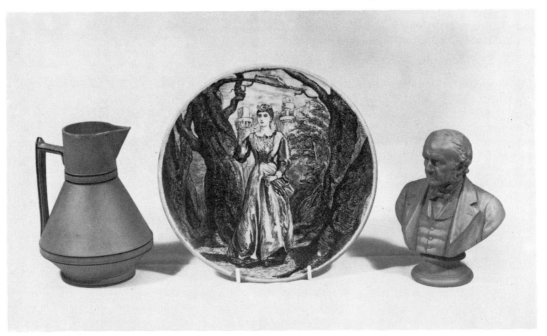

ink drawings copied from book engravings (Fig 53).

In the 1890s competition became keen and new shapes and styles of decoration were introduced. In 1901 the Watcombe Pottery amalgamated with the Aller Vale Pottery to become the Royal Aller Vale and Watcombe Pottery which continued to operate at St Mary Church until 1962, catering largely for the motto-ware market.

The most usual incised or impressed mark on Watcombe wares is simply WATCOMBE TORQUAY. After 1875 a printed mark was sometimes used with the words WATCOMBE SOUTH DEVON on a circular garter enclosing a drawing of a woodpecker, a landscape and a sailing ship.

### The Torquay Terracotta Company

The Torquay Terracotta Company established its pottery in 1875 on a bed of fine quality red clay at Hele Cross. The clay is orange-red, a little lighter in colour than Watcombe clay. The output was mainly of smaller decorative items, especially figures, busts, statuettes, plaques and vases with some domestic items including ewers, basins, butter-coolers, spill cases, toilet trays and tobacco jars. The statuettes were reproductions of work by eminent sculptors such as the 'Tinted Venus' by John Gibson, RA.

Vases and plaques were usually engine-turned before decoration (Fig 53 *left*). *Sgraffito* decoration was used, often after the red body had been covered with a light-coloured slip. The vase (Fig 54), for example, has been decorated with an incised design through slip so that the trailing leaves and flowers are outlined by the red colour of the body. An amber-coloured glaze gives a warm finish. Some vases were painted with flower and bird designs by Alexander Fisher who had come from Stoke-on-Trent. Some wares with glazed decoration were produced but are rare.

The single impressed word TORQUAY was used throughout the life of the pottery as was the impressed or printed monogram TTC designed vertically. The full name of the company was also used but if this includes the words 'Trade Mark' it can be assumed to be post-1900.

### Aller Vale Art Pottery

A pottery between Newton Abbot and Kingskerswell which had been making brown wares from 1865 was taken over in 1868 by John Phillips who attempted to train local workers rather than bring in skilled people from the Potteries. In 1881 a fire stopped production but when the pottery reopened some art wares were made in primitive styles and incised *Phillips Aller*, or *Phillips Newton Abbot*. In 1887 the works became the Aller Vale Art Pottery. Decorative wares were made with *sgraffito* decoration through coloured slip. The patterns were occasionally filled in with coloured glazes (Fig 55 *left*) but the standard method of decorating these scratched wares, which

54. Torquay Terracotta Company vase (*c* 1890) with incised decoration in a covering of slip revealing the terracotta body, the whole covered with an amber glaze. Impressed TTC monogram with the word STAPLETON, possibly the trade name for the design. 33 cm

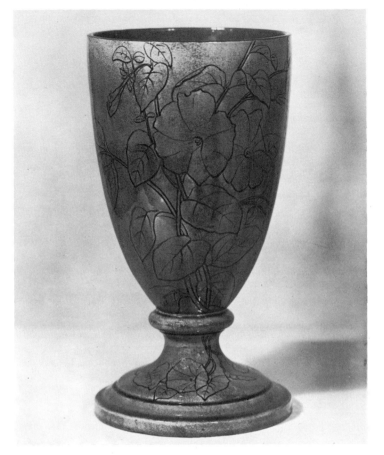

55. Aller Vale Art Pottery. (*left*) Jug (*c* 1890) with pinched and folded rim pierced with a hole through which handle passes. Lower half dipped in cream slip, incised with a design coloured with blue, green and yellow glazes. 14.5 cm. (*right*) Jug (*c* 1900) covered with yellow slip incised with a motto and decorated above and below with brushed-on green and brown slips. 14.8 cm

By doing right you gain the might. To overcome the wrong.

usually carried mottoes, was to brush on coloured slips, usually blue, brown and green (Fig 56 *right*). Patterns solely of flowers and foliage included many with spring flowers; Aller Vale *Crocus* ware used the *art nouveau* style.

After about 1890 the main output was of motto-ware sold not only in the resorts of South Devon but all over the country. An office was opened in Hatton House, Great Queen Street, London and sample boxes were offered for five shillings post free. In 1901 the pottery merged with the Watcombe Pottery, but the name of Aller Vale was used on motto wares for many years. Special orders were taken from individual clients. The beaker to mark the Coronation of Edward VII in 1902 (Fig 56 *left*) is incised 'St Nicholas Shaldon' and was no doubt made for distribution to local schoolchildren. Miss Pamplin who kept *Ye Olde Hostel of God Begot* in Winchester in the years before World War I had plates specially made for publicity purposes (Fig 56 *right*).

At this period there was tremendous competition in the motto-ware field. Longpark Pottery at Torre, started in 1905, also produced art pottery, with more original designs and colours. They adopted a trade name – TUHMOHUN WARE. The Devonmoor Art Pottery started in 1913 at Liverton, Newton Abbot and although it closed in 1914 it reopened in 1922 to make motto-wares. A competitor was also making high-quality motto-wares in Dorset.

## The Wemyss Ware of the Fife Pottery, Kirkcaldy

The Fife Pottery at Kirkcaldy in Scotland was acquired in 1837 by Mary and Robert Heron. They were succeeded by their son,

56. Aller Vale Commissioned Wares from the Royal Aller Vale and Watcombe Pottery at St Mary Church.
(*left*) Edward VII Coronation beaker (1902) for 'St Nicholas, Shaldon' with incised and applied decoration. 11 cm.
(*right*) Souvenir plate (*c* 1908) made for Miss Pamplin who restored the old Tudor Hostel of God Begot at Winchester in 1908. 16 cm. (Mrs D. Curd)

Robert Methven Heron, who had been a partner since 1870. Intelligent and artistic, he had travelled widely in Europe and in 1883 he brought in artists from Bohemia with the idea of developing a new style of painted decoration. The most notable was Karel Nekola who stayed with the firm for thirty years, painting and training others to paint, including his sons Carl and Joseph.

The new painted pottery was called *Wemyss Ware*, a tribute to Lady Henry Grosvenor of Wemyss Castle. It was made from Cornish clay landed at Dysart, and the decoration was painted directly on the biscuit before glazing. The wares fall roughly into three periods though some styles introduced in the early days continued for a long period.

### The First Period, 1883–1900

Early Wemyss wares are usually fairly large so that the painted decoration, mainly of flowers and fruit, has a restrained appearance with plenty of white background. Large toilet sets with ewer and basin etc were very popular and are usually painted with cabbage roses. Tall mugs have a cock-and-hen motif in dark colours and many of the wares have a painted rim, usually red but sometimes green (Fig 57 *left*). Modelled pigs and

57. Wemyss Ware of the Fife Pottery, Kirkcaldy. (*left*) Mug (*c* 1883–95) with overglaze painted cock-and-hen decoration in black and red on green grass, with a red rim. 13.7 cm. (*centre*) Lidded powder-bowl (*c* 1895–1915) with overglaze painted decoration of cabbage roses in pink and yellow-green. 11.2 cm. (*right*) Sandland Period mug (*c* 1916–30) with dark-blue iris on red, yellow and green ground. 13.5 cm. (Huntly House Museum, Edinburgh)

cats were made, and vases with *chinoiserie*. The range of flower decoration included buttercups, Canterbury bells, carnations, irises, lilac, shamrock, sweet peas and violets. Fruits included apples, cherries, lemons, oranges, plums, red currants and strawberries. Each piece usually shows only a single species. The early wares were made for a high-class market and the sole agent in London was Thomas Goode & Co, of South Audley Street.

### The Second Period, 1900–1916

This period was marked by a decline in demand for the larger pieces of Wemyss ware. A new market had to be opened up by producing smaller and less expensive items (Fig 57 *centre*). On many of these the traditional forms of decoration look rather crowded. Commemorative wares, already introduced for Queen Victoria's Diamond Jubilee in 1897, were produced in quantity for the coronations of Edward VII and George V. Special commissions were executed.

In 1910 Nekola's health began to fail; a workshop was built at his home so that he could continue to paint but his influence at the pottery was sadly missed. He died in 1915.

### The Third Period, 1916–1930

By this time the demand for Wemyss ware had fallen off dramatically, largely due to improved domestic lighting and sanitation: toilet sets and candlesticks were no longer wanted. For a year after Nekola's death there was a period of uncertainty. In 1916 Eric Sandland from Stoke-on-Trent became manager. He changed both styles and methods of production. Decoration became more impressionistic and high-temperature firing was introduced (Fig 57 *right*). The name 'Wemyss' was used but many of the wares have little affinity with those of Nekola's time. Flowers were still used for decoration but often on a black background. Sandland died in 1928 and the pottery closed in 1930. The Bovey Tracey Pottery Co acquired the rights and Joseph Nekola moved to Devon to decorate pottery with traditional Wemyss designs.

Most Fife Pottery wares are clearly marked. The word *Wemyss* is usually painted though sometimes impressed, and wares sold in London have the retailer's mark. Occasionally R.H.&S. is found for Robert Heron & Son. After 1920 the full name of the firm surmounted by a thistle was used on hand-painted Wemyss ware.

A few pieces bear the initials of Karel Nekola (KN); others the initials of one of his sons, Carl Nekola (CN), or Joseph Nekola (JN). Such pieces are uncommon but it is always worth looking for the initials of the painters. Local decorators included James Adamson, John Brown, David Grinton, Christina and Hugh MacKinnon and James Sharp.

# The New Approach of the Chemist-Craftsman

At the turn of the century a dramatic change took place in the production of art pottery. A number of highly trained technical men interested in the chemistry of potting and particularly in the use of new glazes opened up a new field. The appeal of many of their wares depended solely on fine potting and unadorned colouring. They included such men as Cuthbert Bailey, Joseph and William Burton, William Moorcroft, Bernard Moore, Charles Noke, John Slater, W. Howson Taylor and Pascoe Tunnicliffe. Their discoveries were mainly made between the late 1890s and 1914. Some were used later by other potteries. Bernard Moore, for example, became a ceramic consultant in 1915 and helped other firms with their problems. The potteries which were involved in producing the new-style wares are dealt with in turn.

## Adamesk Art Pottery

This was the name given to the wares made by Adams & Co of Scotswood-on-Tyne, Northumberland between 1904 and 1914. Moses J. Adams was responsible for this side of the output. Adamesk wares were made from a local fireclay treated with coloured feldspathic glazes. Pieces are usually impressed with the trade name ADAMESK and sometimes bear the incised initials of Moses J. Adams – *MJA*. The production of art pottery was revived by his son Alan H. Adams after World War I. He also signed some of the wares he designed and introduced a new style known as ELANWARE. There is an account of the pottery in R. C. Bell's *Tyneside Pottery* (1971).

## Allander Pottery, Milngavie, Dunbartonshire

A small pottery at Milngavie was established by Hugh Allan in 1904. All the wares had coloured and crystalline glazes, and examples are not common since the works closed in 1908. The pieces bear an incised or painted mark with the name ALLANDER, HA for Hugh Allan, and a date.

## Ashby Potters' Guild

Ashby Potters' Guild was established in 1909 at Woodville, Derbyshire by Pascoe Tunnicliffe, a chemist potter. He acted as director and produced what was known as 'Vascoe Ware' from 1909 until 1922. Each piece was the idea of a single craftsman and all the pots were turned on a wheel. Their attraction lies in their leadless glazes which include blue, moss green, and rouge flambé. The pottery mark consists of the impressed words ASHBY GUILD within an oval. Incised initials of artists are sometimes found. ABR and JWD have been noted.

## Doulton and Royal Doulton Burslem Wares

The work of three men at the Doulton works in Burslem led to the production of several new types of art pottery. They were John Slater, the art director; Charles J. Noke, a modeller from 1889 who succeeded Slater in 1914; and Cuthbert Bailey who joined the firm in 1901. Over many years the following wares were introduced:

58. Royal Doulton 'Sung' elephant (*c* 1920) by Charles Noke, the pachyderm with a mottled runny green-to-blue glazed body, its head a brilliant dark red. Painted mark: 'Sung' Noke, Doulton, England. 46 cm. (Sotheby's)

*Holbein Ware* (1895), decorated with inlaid portraits of contrasting colours.

*Rembrandt Ware* (1898), decorated with layers of coloured slip with designs based on Rembrandt paintings.

*Flambé Ware* (1904), in which a high-temperature glaze covered a design painted in black.

*Titanian Ware* (*c* 1915), with an unusual blue glaze containing titanium oxide.

*Sung Ware* (1920), in various colours, often with a flocculent blue glaze over a painted design.

*Chang Ware* (1925), with several layers of thick, opalescent and brightly coloured glazes overrun by a crackled glaze flowing down the surface.

The marks usually give the trade name of the type of

**Holyrood Pottery**

343 · 500 · 501 · 344 · 502 · 504 · 505 · 340 · 340A · 503 · 312 · 311A · 338 · 345 · 506 · 2A · 321A · 528 · 346 · 349M · 334 · 193 · 192 · 507 · 131 · 210 · 349S

59. Cover (*opposite*) and a typical page from a catalogue of the Holyrood Pottery in the 1920s. (Mrs H. Wannop, Edinburgh)

decoration and the monogram of the artist. Artists included Harry Allen, Arthur Eaton, F. Henri, William G. Hodgkinson, Fred Moore, Harry Nixon, C. J. Noke, Walter Nunn, Edward Raby and Harry Tittensor.

## Holyrood Art Pottery, Edinburgh

Henry T. Whyse, a furniture designer, was also an art master at Arbroath in the 1890s. He later became a lecturer at Moray House Training College in Edinburgh and in 1918, or possibly a little earlier, established a small pottery at 34 Bristo Street where he made ceramic buttons, small plaques from which calendars could be hung, and what he described as 'Waverley Ware' with moulded designs in the *art nouveau* manner. He was forced to move when a neighbour living in a flat above the kiln complained that her cat's feet were getting too hot. New premises were obtained in Boroughloch Square. By 1923 the

60. Moorcroft *Florian* vase
(*c* 1902–05) painted with pink
and blue roses and green
foliage outlined in slip on
white ground. Macintyre
*Florian Ware* mark transfer-
printed in brown. Painted
signature – *W. Moorcroft*.
23.4 cm. (Miss J. Allport)

firm of Whyse and Isles (Isles helped with finance) were producing 'Holyrood' wares decorated with coloured leadless glazes which were allowed to run down over the surface giving a mottled or streaked appearance. An undated catalogue survives (Fig 59) which gives over 500 different shapes and reveals that 'Green & Co' retailed the wares. The mark is an impressed cross within a circle surmounted by the word HOLYROOD (a simple version of that on the catalogue cover). The Holyrood Pottery closed in 1927.

## William Moorcroft of Burslem, Staffordshire

In 1897 William Moorcroft became a designer for James Macintyre & Co of Burslem. They set aside part of their works for art pottery and gave William Moorcroft full responsibility with a studio and two workshops. He had a thrower, a turner and two decorators to work with him.

The earliest commercial art pottery produced was transfer-printed in underglaze colours. At the same time Moorcroft was experimenting with slip-trailed wares sold under the name of *Gesso Faience*. Within a year he had launched his famous *Florian Ware* which became a bestseller. The name was given to pottery with a white body decorated with stylised flowers and leaves, each flower and leaf outlined in white slip and painted, usually in blue or green, before glazing (Fig 60). The slip served to limit the colours to specific areas and to prevent them from merging during the high-temperature firing. Within a short time *Florian Ware* was being sold by Liberty in London, Tiffany in New York, Shreve in San Francisco and Rouard in Paris. The output included a wide variety of shapes and types of decoration, sold under trade names such as *Claremont* (a toadstool design), *Hazledene* (a landscape with trees), *Honesty, Pansy, Pomegranate* (sold by Liberty as *Murena*), and lustre wares made for Liberty as *Flamminian*. The association with this firm led to a close friendship between William Moorcroft and the Libertys. A commemorative mug was made for their special use when Edward VII was crowned (Fig 61 *left*) and a Peace mug (Fig 61 *right*) was made for Lady Liberty during her widowhood.

In 1913 Macintyre & Co ceased to make art pottery and Moorcroft decided to set up on his own at Burslem, taking with him some of the decorators and retaining the goodwill of the *Florian Ware* retailers. He supervised every detail himself and soon introduced new lines including *Powder Blue* tablewares. Early patterns such as *Hazledene* were revived with variations and with great success (Fig 62). However, Moorcroft's main interest became flambé or transmutation glazes and in 1919 he built a special kiln to fire them. He worked on these for the last twenty years of his life and won many awards for flambé wares in Paris, Brussels and America.

In 1928 William Moorcroft was appointed Potter to HM The

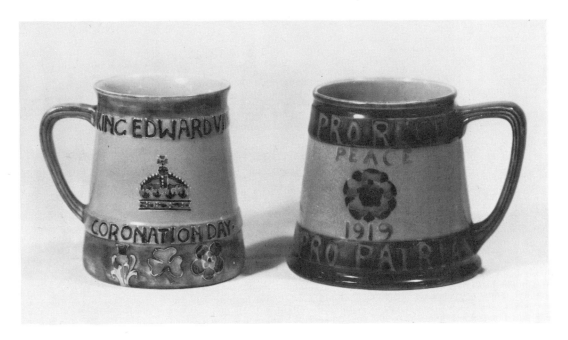

61. Moorcroft Commemorative mugs made for Lasenby Liberty and his wife. (*left*) Mug painted in tones of green with Royal insignia and national flowers and inscribed: Edward VII Queen Alexandra Coronation Day June XXVI MDCCCCII. 10.2 cm. (*right*) Mug painted in green and red with Royal insignia and national flowers and inscribed: August 4th 1914 November 11th 1918, PRO REGE, PRO PATRIA, PEACE 1919. 10 cm. The Coronation mug has the transfer-printed inscription on the base: 'From Mr and Mrs Lasenby Liberty The Lee Manor Bucks'. The Peace mug simply 'From Lady Liberty'

Queen, but he began to find it increasingly difficult to sell his wares on the home market, though the demand from abroad was still steady. Attempts were made to meet the demands of fashion in the 1930s and new designs were introduced with leaves and fruit (Fig 62 *right*) and vases with decorative bands combined with early *Florian* designs. The outbreak of war in 1939 dealt the export trade a severe blow, but despite many problems Moorcroft managed to keep his overseas connections. He died in 1945 and his son, just returned from active service, took charge of the pottery.

Moorcroft wares may be roughly dated by their marks:

*The Macintyre Period, 1897–1913.* The name Macintyre & Co is transfer-printed in brown or there may be a retailer's mark in brown, eg 'Made for Liberty & Co'; 'Made for John Walsh & Son Ltd., Sheffield'; or 'Made for Osler, London'. The Osler pieces carry the trade name *Hesperian*. Most wares bear the initials or signature of W. Moorcroft painted in green, followed by *des* (designer).

*Burslem Mark, 1913–1921.* When he started on his own MOORCROFT BURSLEM was impressed in two lines, and by 1916 ENGLAND was added. The painted signature continued.

*Made in England Mark, 1921–1930.* BURSLEM was now dropped from the mark and England became 'Made in England'. Painted signatures continued.

*The Royal Mark, 1930–1945.* When Moorcroft received royal patronage he decided in 1930 to impress the words POTTER TO H.M. THE QUEEN in addition to the previous mark and often used an impressed facsimile signature. Printed

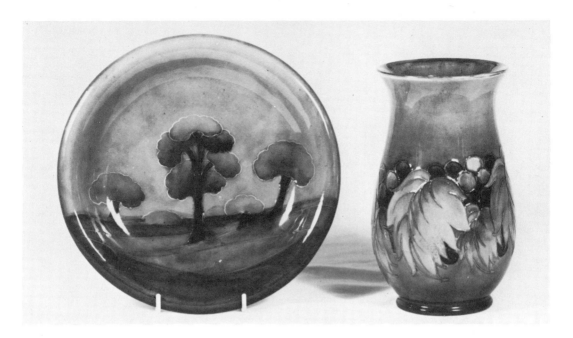

'By Appointment' paper labels were used from about 1930 but it is unwise to depend on these when dating wares. Unmarked wares which suggest a Moorcroft origin should be treated with suspicion: a number of imitators tried to copy his technique and his colours.

A catalogue of an exhibition at the Fine Art Society in 1973 published under the title *William Moorcroft and Walter Moorcroft 1897–1973* is the most comprehensive work on the subject.

62. Moorcroft Cobridge (Burslem) Wares. (*left*) Shallow dish (*c* 1916–21) with *Hazledene* landscape pattern in shades of blue and olive-green outlined in slip. 22.3 cm. (*right*) Vase (*c* 1935) with fruit pattern in shades of blue and olive-green outlined in slip. 19 cm

## Bernard Moore, Stoke-on-Trent, Staffordshire

After years of experience in the ceramic industry, Bernard Moore set up in business in 1905 in Stoke-on-Trent and within a year was joined by his son, Bernard Joseph Moore. As a chemist Moore was particularly interested in glazes and in trying to reproduce some of the glaze effects on oriental wares. His experiments led to the production of fine rouge flambé, turquoise and sang-de-boeuf glazes as well as fine lustres. The vases were often decorated beneath the glaze with flowers, flying birds and other motifs, and most of the artists signed their work. They included John Adams, Hilda Beardmore, Dora May Billington (from 1912), George Allen Buttle, Gertrude Jackson, Hilda Lindop, Annie Oliver, Reginald R. Tomlinson and Edward R. Wilkes.

In 1915 the Bernard Moore pottery closed after ten years of operation during which the same marks were used – either the initials BM painted on the wares or the full name BERNARD MOORE painted or printed, sometimes with a date.

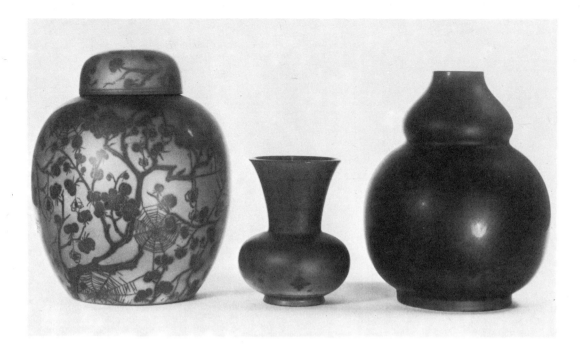

63. Bernard Moore Pottery.
(*left*) Jar and cover (1905–15) decorated by Hilda Lindop with prunus blossom and spiders' webs in a flambé glaze on ground varying from grey to sand. Artist's monogram. (*centre*) Vase (1905–15) by Hilda Lindop decorated with stars in a flambé glaze on stone ground. 15 cm. (*right*) Gourd-shaped vase (1912–15) by Dora Billington decorated in deep flambé glaze on dark-grey ground. 24 cm. (Sotheby's)

## Pilkington's Lancastrian Pottery, near Manchester

The Pilkington Tile and Pottery Co was established in 1891 after borings for coal had revealed clays suitable for making bricks and tiles. William Burton, a brilliant chemist who had been working for Wedgwoods, became technical and artistic director in 1892 and was joined by his brother Joseph. They worked together on glazes. At first only tiles were made, but by 1897 some vases and buttons with crystalline glazes were added. Some were designed by John Chambers who had also come from Wedgwoods. He introduced 'kylix' shapes based on an ancient Greek style. The art pottery side soon developed rapidly and skilled artists, designers and craftsmen were recruited. Abraham Lomax who was chemist at the works from 1896 to 1911 recognizes three main periods of development.

### The First Period, 1900–1904

The output consisted of simple attractive shapes with fine glazes. The form of the pots owed much to Edward Thomas Radford, a skilled thrower from the Linthorpe Pottery. He was at the Lancastrian Pottery for over 30 years and some of his later work is incised *E.T.R.*

Two of the early glaze effects were *Sunstone*, a glaze full of glittering crystals, and *Eggshell*, so-named because of its fine texture. A new ultramarine-blue glaze was produced for the first time in 1903 by using zinc oxide with cobalt oxide. A range of these wares, marketed under the name *Lancastrian*, was exhibited in 1904.

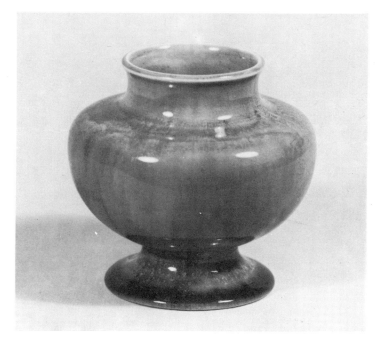

64. Pilkington's Lancastrian vase (1912). The ultramarine glaze has been allowed to run to produce a deeper colour at the foot. Impressed 'Bees' mark with ENGLAND XII. 9 cm.

## The Second Period, 1904–1908

Experiments continued and new glazes using uranium were introduced – *Uranium Orange* and *Uranium Orange Vermilion*. Perhaps the most notable achievement was the discovery that it was possible to paint an iridescent lustre on the wares in such a way that it would stain an already-fired glaze. A special muffle kiln was built to fire these lustres and Gordon M. Forsyth, an experienced designer and painter from Minton, Hollins & Co, supervised production. He painted many pieces himself and encouraged other artists working in this field.

## The Third Period, 1908–1938

This was a period of free expression. The thrower was urged to produce his own designs and many new shapes emerged. Artists were also expected to express their individuality and to sign their work, a practice particularly welcomed by retailers in America. Lustre painting predominated, but wares with matt-surfaced glazes were decorated with brown and black enamels, and a certain amount of *sgraffito* work and modelling was done. Richard Joyce spent much time modelling animals and birds.

From 1913, as the result of royal patronage, the wares were known as *Royal Lancastrian*. The outbreak of war in 1914 and the retirement of William Burton in 1915 seriously affected output. Two key members of staff, C. E. Cundall and G. M. Forsyth, joined the forces and did not return to Pilkington's after the war. Although lustre painting continued there were few innovations as the firm had no works chemist until 1927 when Arthur Chambers, son of the first designer, was appoin-

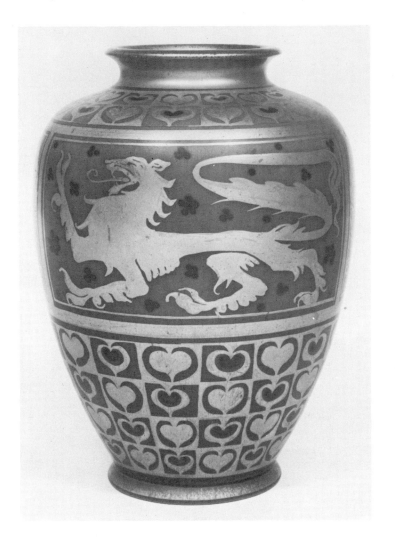

65. Pilkington's Lancastrian
vase (1907) by Gordon M.
Forsyth decorated in silver,
ruby and blue lustre with
panels of a lion passant, the
shoulders and foot with bands
of hearts. 'Bees' mark and
artist's rebus. 19.7 cm.
(Sotheby's)

ted. Lustre painting ceased in 1928 and a new style of dec-
oration was introduced. Colour was applied to the biscuit and
the wares were then glazed. During the firing, pigment and glaze
merged to produce mottled colours with blurred edges. This
new way of decorating pottery soon became popular and
formed a major part of the output. It was known as *Lapis
Ware* since it had the appearance of lapis-lazuli.

Unfortunately the factory never recovered from the death of
Joseph Burton in 1934. The directors refused to cheapen their
products by sacrificing quality and economic conditions forced
the closure of the pottery in 1938.

Six artists and designers stand out above all others employed
by Pilkington's.

*Charles E. Cundall* joined the firm in 1907 and was noted for
his painting of lustre wares, which he signed CEC with the
second C reversed.

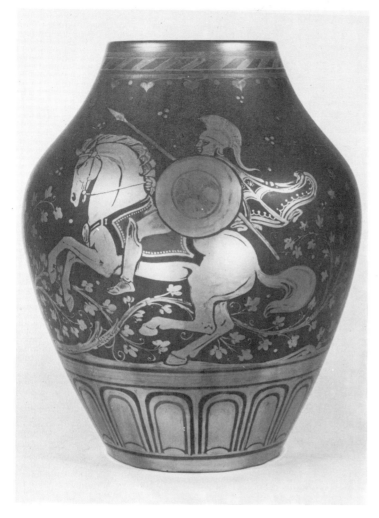

66. Pilkington's Royal Lancastrian vase (*c* 1920) by Richard Joyce. Gold lustred with Grecian warriors on prancing steeds on a minutely speckled bright-blue ground, details of trappings picked out in ruby. Impressed rosette mark and RJ monogram. 30.5 cm. (Sotheby's)

*Gordon M. Forsyth* specialised in silver lustre designs on various grounds, including uranium orange, flambé and underglaze green. He was particularly fond of heraldic designs (Fig 65). His monogram consists of four interlacing scythes.

*Richard Joyce* worked in the firm from 1905 until his death in 1931. He decorated more fine pieces of Lancastrian ware than any other artist and could turn his hand to any aspect of the craft – modelling, carving or painting. He favoured natural subjects – flowers, animals (including leopards carved in low relief), and fish among seaweed. However, he was equally at home with classical subjects (Fig 66). His square seal-type monogram shows his initials, RJ.

*Walter Salter Mycock* started in Pilkington's tile section and moved to the art pottery department in 1904 to paint lustre wares. He favoured silver lustre (Fig 67) often on uranium-orange and orange-vermilion glazes and his designs were more

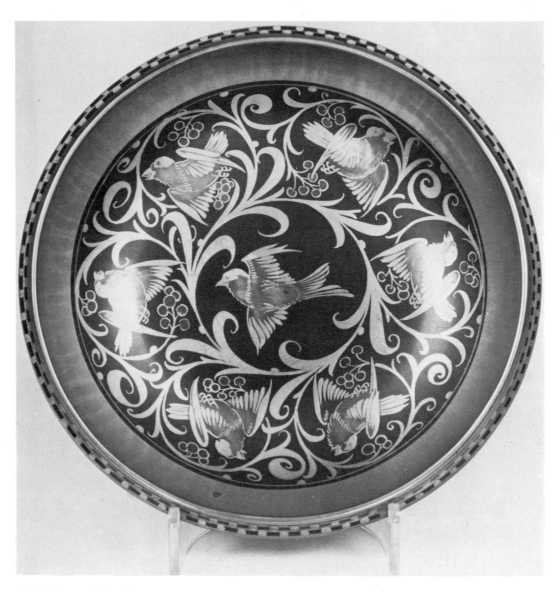

67. Pilkington's Royal Lancastrian lustre bowl (1927) by W. S. Mycock, the shallow body with a large central panel of six gold and silver bullfinches with iridescent bodies flitting among ruby-berried leaf scrolls, all on a midnight-blue ground. Impressed rosette mark, WSM monogram. 33 cm. (Sotheby's)

conventional than those of Forsyth and Joyce, but he was a very fine craftsman and won a gold medal for his work at the Paris Exhibition of 1925. He stayed with the firm until 1931.

*Gwladys M. Rodgers* joined Pilkington's at about the same time as Gordon Forsyth. She painted lustre wares but was able to cover a wide range of styles and after 1928 worked on *Lapis Ware*.

*Walter Crane* did freelance design work between about 1907 and 1910. His designs were executed by Charles Cundall or Richard Joyce.

Other well-known artists included Lewis F. Day, Jesse Jones, (whose monogram included a thistle), Annie Burton who

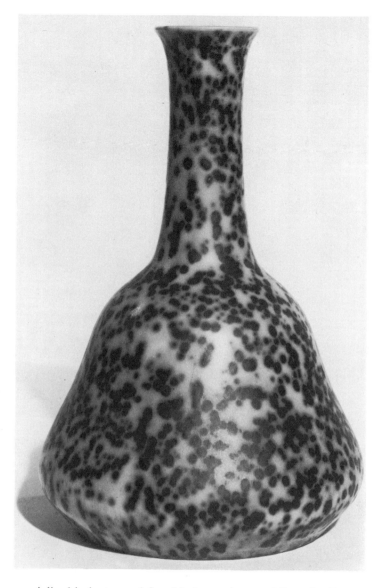

68. Ruskin high-fired vase (1908) black-speckled over a spumy-white, sea-green ground breaking over patches of streaky purple. 23 cm. (Sotheby's)

specialised in lustre and flambé decoration, and Dorothy Dacre.

First Period Lancastrian pottery was either unmarked or carried an incised P. From 1908 to 1914 a seal mark with a P combined with two honeybees (representing the Burton brothers) was introduced, first printed and from 1909 impressed. Dates are indicated by Roman numerals, eg XII is 1912. In 1914 a new mark was introduced for 'Royal Lancastrian' wares. It consisted of a Tudor rose encircling a P, sometimes with the words 'Royal Lancastrian' added. All these bear the word ENGLAND; after 1920 this became MADE IN ENGLAND. Important pieces bear the monogram of the designer or painter.

69. Ruskin high-fired vase (1907) decorated with an ox-blood glaze on a white body, freckled with turquoise spots, one side with a milky-turquoise splash. 19 cm. (Sotheby's)

## Ruskin Pottery, Smethwick, Worcestershire

Ruskin Art Pottery owes everything to W. Howson Taylor. At an early age he decided to win a reputation as an art potter. He started in 1898 in an old malthouse at Smethwick using a local clay and doing everything by hand. Later he used china clay and calcined flint to produce a fine white body.

Two great influences moulded Howson Taylor's outlook, an intense admiration of Ruskin and a deep appreciation of the Chinese pottery of the Sung and Ming periods. He subscribed completely to Ruskin's view that 'life without industry is guilt and industry without art is brutality'. He tried to emulate Chinese glazes and in due course succeeded in producing pottery that was widely admired. He gained permission to call this 'Ruskin Pottery'. It falls into three main types:

*Soufflé Wares* were decorated with a single colour with a range of shades. Mottled milky greens would run down to sage green; a lemon-yellow glaze would grade to an unripe lemon-green.

*Lustre Wares* were also made in a wide range of colours embracing every shade in the spectrum.

*High-Fired Wares* were Howson Taylor's great pride. He did not hesitate to produce them at a loss, subsidising them from his other output. They were truly experimental since the high-temperature firing made it impossible to guarantee a pre-determined result. Most of these wares are mottled (Figs 68 and 69) and have magnificent colouring. They have always been greatly prized by collectors. Saleroom descriptions give some idea of their character. 'Oatmeal brown and pale grey splashed with red'; 'green glaze strongly speckled with black spots and faint splashes of purple'; 'Blood red to murky purple freckled with black spots'; 'Separated malachite-green glaze exposing a creamy ground speckled purple'.

W. Howson Taylor continued to produce Ruskin Pottery, supervising every detail, until his death in 1935, but before he died he destroyed all his papers and potting materials. Having done so he wrote to a friend: 'Why let another firm make rubbish and call it Ruskin?'

Ruskin wares are marked. Early impressed marks include the name TAYLOR, or the incised initials WHT in monogram form with a mark resembling a pair of scissors. After 1904 the word RUSKIN appears in all marks, often with the date. A valuable account of *Ruskin Pottery* by James H. Ruston was published in 1975 by the Metropolitan Borough of Sandwell.

## Silchester Ware by Grovelands Potteries, Reading

Grovelands Potteries, established in the middle of the nineteenth century by S. & E. Collier, produced terracotta and brownwares. Their production of a special kind of art pottery was inspired by the extensive excavations on the Roman site of

Silchester between 1890 and 1909. Towards the end of this period their *Silchester Ware* was produced. This has a dark terracotta body usually covered with a very dark thick brown glaze with a metallic sheen, though blue has also been noted. Some of the shapes are said to have been based on the shapes of vessels unearthed during the excavations. They are impressed SILCHESTER WARE in long narrow letters within a pointed oval.

70. *Silchester Ware* vase (*c* 1910) by S. & E. Collier of Grovelands Potteries, Reading; black flown glaze on red body. Impressed marks: SILCHESTER WARE within a pointed oval, S & E C, and 405. 12.5 cm. (Mr and Mrs Derek Styles)

# Industrial Art Pottery between the Wars

After World War I much of the finest decorative pottery was made by individual potters working in their own potteries. Some artists, however, worked within industry producing styles of decoration bearing their own stamp.

71. Clarice Cliff vase (*c* 1930) painted with a landscape in bright shades of yellow, orange, red and green, with black, on cream ground. Printed marks: FANTASQUE HAND-PAINTED *Bizarre by Clarice Cliff* Newport Pottery England. 28 cm. (Miss Jane Allport)

72. Clarice Cliff chamber-pot (*c* 1930) with crocus design of blue, orange and purple flowers among green leaves rising from an orange-brown base; rim bright yellow with a green band. Printed marks: Wilkinson England *Honeyglaze* Hand Painted *Bizarre by Clarice Cliff* Newport Pottery. Painted mark in green: CROCUS. Diam 22 cm

## Clarice Cliff Designs

Clarice Cliff was apprenticed in the mid-1920s to the firm of A. J. Wilkinson. She was given the opportunity to experiment at their Newport Pottery where she developed a characteristic style using bold designs and strident enamel colouring. To the surprise of her employers these hand-painted designs in the *art deco* style were immensely popular. Within a relatively short time the potting was all transferred to their Royal Staffordshire Pottery and the Newport Pottery was given over entirely to decoration which employed some 300 painters.

In the 1930s Clarice Cliff became Art Director for both factories. The wares all bear her facsimile signature and are grouped as *Bizarre* or *Fantasque* though occasionally both these names appear on the same piece. Individual designs include *Biarritz, Canterbury Bells, Celtic Harvest, Crocus* and *Ravel*. Some designs were abstract and geometrical; others included stylised flowers (Fig 72), trees or landscapes (Fig 71). All are very clearly marked.

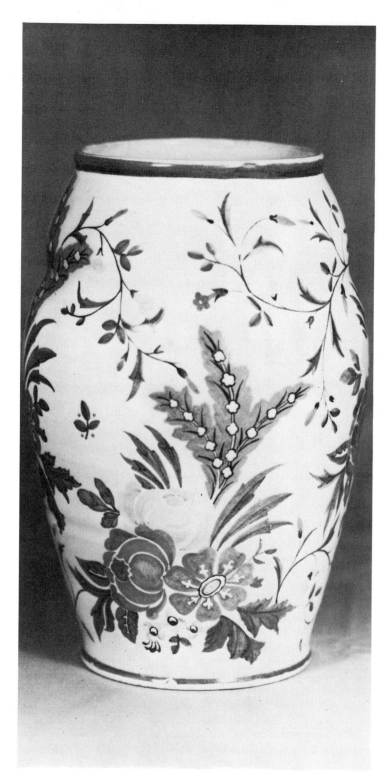

73. Poole Pottery vase (1921–5) with hand-painted decoration of flowers and leaves in bright shades of yellow, red, blue, brown and green on an off-white ground, the whole with a matt glaze. Impressed mark: CARTER STABLER ADAMS POOLE ENGLAND. 36 cm

74. Poole Pottery jug (1920s) with combed slip decoration in white, dark-brown and dark-blue. The salmon coloured body is exposed in lip and handle, the whole lightly glazed. Incised mark: POOLE ENGLAND 730. 15.5 cm

## Keith Murray of Wedgwoods

Keith Murray was an architect and designer who joined Wedgwoods in 1933. He started to design elegant vases and bowls in the style of early Chinese and Korean wares, using engine-turning to give a smooth finish and usually decorating with lathe cuts in grooves and bands. His pieces are mainly cream or the grey-green of celadon and have a matt or eggshell finish which does not distract attention from appreciation of the shapes. He sometimes used a coloured slip, engine-turned to reveal a different colour beneath. His work bears his name and

sometimes a title, eg *Moonstone*, together with a printed or impressed Wedgwood mark.

## The Poole Pottery of Carter, Stabler & Adams

The development of the Poole Pottery under Owen Carter has been described (p 43). When he died in 1919 responsibility fell on his brother, Charles Carter, who decided to take advice from Harold Stabler, a noted designer. A new company, Carter, Stabler and Adams, was formed in 1921 as a subsidiary of Carter & Co to develop a new kind of art pottery, and the second period of Poole Pottery was initiated. Cyril Carter became director, John Adams was the managing director and his wife Truda chief designer. Harold Stabler was the artistic consultant.

An entirely new type of art pottery was introduced using established tile techniques of decoration with simple brushwork designs in a contemporary style. The wares were hand-thrown, most of them of the delft type, hand painted with flower sprays and other patterns. They were treated with a fine matt glaze. These wares, decorated mainly in shades of blue, green and purple, soon became widely known as 'Poole Pottery'. Other types of decoration were also introduced. Some combed slip-wares (Fig 74) were made and coloured glazes were used on wares which were given trade names – *Chinese Blue, Apple Green, Zulu Black, Vellum White* and *Tangerine*. There was also a *Sylvan* range of matt speckled glazes in delicate shades of blue, brown, green and yellow. However, the painted wares were the most successful, especially in America.

75. Poole Pottery. (*left to right*) Vase (1921–5) with green, grey and yellow painted decoration. Incised number 353. 9 cm. Jam pot (1921–5) with *art deco* style decoration in yellow, brown, grey and black. Incised number 286. 10.6 cm. Two-handled vase (1925–40) painted in purple, green and orange with stylised fruit and leaves. Handles and interior pale mauve. Incised number 202. 16.6 cm. Vase (1925–40) painted in bright shades of purple, green, red and orange. Incised number 959. 11 cm

The artists and designers at Poole worked as a team and although their initials often appear on the wares it is not easy to identify particular individuals. Dora M. Batty painted many nursery mugs with ducks and rocking-horses. Eileen McGrath painted nursery pieces with circus performers. Marjorie Drawbell and Minnie McLeish were also skilled painters.

It is easy to distinguish early wares from the Poole Pottery of today. Between 1921 and 1925 they were impressed with a seal mark of Carter Stabler & Adams or simply POOLE ENGLAND on a salmon-coloured body. From 1925 the company name is followed by 'Ltd'. By 1930 the colour of the body had changed to white or pale cream. From this point output declined owing to the trade recession after the Wall Street crash of 1929–30.

# The Rise of the Studio Potter

Studio potters have been aptly described as artist-craftsmen carrying out their own ideas mainly with their own hands and at their own tempo. Several potters were working in this way before World War I. William Dalton and George Cox worked in London; W. & J. Baker and Reginald Wells in Kent, at Upchurch and Rainham respectively. After World War I there emerged a number of artist-potters who set new standards and shared their experience with others both at home and abroad. Among them five names stand out – Bernard Leach, William Staite Murray, Michael Cardew, Charles and Nell Vyse. They have all had a profound effect on studio pottery production which still flourishes and enriches our culture.

76. St Ives Pottery stoneware plate (*c* 1930–40) with wave decoration in dark-brown and blue-grey slip. Impressed seal mark of the pottery. 22.5 cm

## Bernard Leach

Born in Hong Kong in 1887, he studied in Britain at the Slade School of Art. He returned to Japan at the age of 21 to teach, but soon felt an urge to study pottery and became the sole pupil of Ogata Kenzan. He met Shoji Hamada who had studied at the Kyoto School of Pottery and from 1920 they worked together in England for three years and established a pottery at St Ives in Cornwall, using a wood-fired kiln. Hamada then returned to Japan. The wares made at St Ives included a low-temperature faience called 'Raku' using Japanese methods, some English slipware and stonewares fired at a high temperature.

Slowly the work at St Ives came to be known and its influence spread largely through a succession of student-apprentices including Michael Cardew, Katherine Pleydell-Bouverie and Norah Braden, who all became fine potters in their own right. In 1933 Leach's son, David, took charge at St Ives for short periods while Bernard Leach taught at Shinner's Bridge, one of the Dartington Hall enterprises in Devon. Here he developed the English slipware technique using chocolate-coloured clay from Fremington in North Devon. In 1934 he again went to Japan. Laurie Cookes and Harry Davis ran the St Ives Pottery, producing slipware on a considerable scale. In 1937, when Bernard Leach had returned, the pottery kiln was converted to use crude oil.

During World War II a land mine all but destroyed the pottery. Bernard Leach has described his methods fully in *The Potter's Book* (1940).

## William Staite Murray

He too had a great influence on young potters as a teacher. He learned his craft at the Camberwell School of Art and started experiments at Yeoman's Row, South Kensington in 1919. He later set up a pottery at Rotherhithe. His early pieces carry a scratched signature but he soon began to use a hexagonal seal mark with the letter M. His next move was to Brockley Heath in Kent, though he took his pots to Bermondsey to be fired. However, he soon built an oil-fired kiln – a real innovation for a studio potter. His next pottery was at Bray in Berkshire and he used this throughout the period when he was teaching at the Royal College of Art, South Kensington. In 1940 he went to Rhodesia.

Staite Murray was greatly influenced by Chinese wares, especially by those of the Sung dynasty. He specialised in decorative stonewares with blue and green glazes, and regarded his work as being as important as that of a painter of portraits or landscapes. He gave each of his pieces a title such as 'Aulos' (Fig 77) 'Claire de Lune', 'Pine' or 'Summer River'. His late work included a number of very long narrow vases.

77. William Staite Murray
two-handled vase (*c* 1935)
entitled 'Aulos' of brown
stoneware with pale-brown slip
decoration and *sgraffito* motifs
on the shoulder. 32.5 cm.
(Southampton Art Gallery)

## Michael Cardew

A Cornishman, he had his interest aroused in pottery when as a
small boy he was taken to watch Edwin Beer Fishley at work in
Fremington, North Devon. After some time at St Ives he went
to Winchcombe in Gloucestershire, and in 1926 adapted an
old flower-pot factory to produce studio pottery. At first he
brought in clay from Fremington but soon started using a local
clay. He made highly individual lead-glaze pottery (Fig 78)
and slipwares, producing some of his finest work. In 1939 he
moved to Wenford Bridge in Cornwall and experimented with
stoneware and tin-glazes. In 1942 he left England to take
charge of pottery in Achimota College in the Gold Coast,
since when he has spent most of his time teaching and potting
in Africa.

78. Michael Cardew jar (*c* 1930) with brown galena glaze superimposed with a black glaze which has been cut away to form the surface pattern. The glazes stop above the base revealing a red clay body. Seal marks MC and WP for Michael Cardew, Winchcombe Pottery. 37 cm

79. Charles Vyse figure of a naked girl riding a cockerel (*c* 1930), the bird with pinky red wattles and grey, blue and purplish feathers on a flower-painted base. The whole in subtle enamels. Incised C. Vyse Chelsea. 30.5 cm. (Sotheby's)

## Charles and Nell Vyse

They established a studio and kiln at Cheyne Row, Chelsea in 1919. Charles had had a distinguished career before starting on his own. He had been apprenticed to a Staffordshire firm as modeller and designer, had won a number of art scholarships and in 1911 had been elected a member of the Royal Society of Sculptors. Working with his wife, Nell, he started to produce sculptured figures and groups (Fig 79). He drew the groups, modelled them, and his wife was responsible for the colouring and glazing.

They were both fascinated by Chinese and Japanese wares and were able to study these in the famous collection of a neighbour, George Eumorfopoulos. By 1929 they had widened their field to include the production of stonewares in the Chinese style, fired in a gas kiln constructed to withstand high temperature. Great care was taken with the stone-grey crackle and black orange-skin glazes inspired by their Chinese counterparts.

80. Sam Haile stoneware vase (1936) potted with pronounced rings in a heavily grogged grey body and painted in brown with human figures under a grey-green glaze stopping high above the foot. Impressed monogram. 20.2 cm. (Sotheby's)

In 1940 an air-raid damaged their premises but they started up again after the war.

Vyse pottery is marked with impressed, incised or printed name or initials, usually with the year of origin.

### Thomas Samuel Haile

One of Staite Murray's most brilliant pupils, Haile taught at Leicester, Kingston and Hammersmith and developed an individual style of potting influenced by surrealism. In 1938 he married Marianne de Trey and went with her to America to teach in the New York College of Ceramics. From 1943 to 1945 he served in the army and then went to Bulmer's brickyard in Sudbury, Suffolk where he made slipwares and fired them in a brick kiln. In 1947 he worked with his wife at Shinner's Bridge, Dartington, Devon, but met a tragic death in a car accident a year later.

Much of Haile's stoneware was painted (Fig 80) and in many cases he gave his pieces a title: 'Serenity', 'Cretan Feast' and 'Roman Baths' are examples.

# Further Reading

The following books give valuable information about art pottery:

Blacker, J. F. *The ABC of English Salt-Glaze Stoneware* (1922)

Bradley, R. J. *Castle Hedingham Pottery, 1837–1905* (1968)

Dennis, R. *Doulton Stoneware and Terracotta, 1870–1925* (1971)

Dennis, R. *William and Walter Moorcroft, 1897–1973* (1973)

Dennis, R. *Doulton Pottery from the Lambeth and Burslem Studios, 1873–1939* (1975)

Dennis, R. and Jesse, J. *Christopher Dresser* (1972)

Eyles, D. *Royal Doulton, 1815–1965* (1965)

Eyles, D. *The Doulton Lambeth Ware* (1975)

Gaunt, W. and Clayton-Stamm, M. D. E. *William De Morgan* (1971)

Haslam, M. *English Art Pottery 1865–1915* (1975)

Holland, W. F. *Fifty Years a Potter* (1958)

Leach, B. *A Potter's Book* (1940)

Le Vine, J. R. A. *Linthorpe Pottery, An Interim Report* (1970)

Lomax, A. *Royal Lancastrian Pottery, 1900–1938* (1957)

Rose, M. *Artist Potters in England* (1955)

Ruston, J. H. *Ruskin Pottery* (1975)

Thomas, E. L. *Victorian Art Pottery* (1974)

Wakefield, H. *Victorian Pottery* (1962)

Wingfield-Digby, G. *The Work of the Modern Potter in England* (1952)

# Acknowledgements

While preparing this book I have been able to examine a great many examples of art pottery in antique shops, auction rooms, museums and private collections. For generous help I am therefore indebted to a great many people but particularly to Miss Jane Allport, Mr Wilfred Blunt, Mrs K. A. R. Coleman, Mr and Mrs Anthony Fields, Mr George Gibb, Mr Robin Hill, Mr Gavin Nettleton, Professor J. S. A. Spreull, Mr and Mrs Derek Styles, The Colchester and Essex Museum, The Huntly House Museum, Edinburgh, Sotheby's, Southampton Art Gallery, and the Victoria and Albert Museum. I also owe a special debt of gratitude to Mr Richard Clements who took most of the photographs.

A. W. Coysh

# Index